Collins *gem*

Insects

KU-441-008

Michael Chinery

Photographic Consultant
Bob Gibbons

HarperCollins*Publishers*
77-85 Fulham Palace Road, London W6 8JB

First published 1997
This edition published 2004

10 9 8 7

ISBN-13: 978 0 00 714624 6

www.collins.co.uk

Printed in China by Leo Paper Products

Contents Key

The insects described in this book belong to 15 orders, each of which is briefly described here. Each one has a small symbol depicting the typical shape and appearance of its members, although some of the larger orders contain insects of very varied appearance. Comparing the symbols with insects that you find will enable you to place the insects in their correct orders. By turning to the appropriate section in the body of the book, you may be able to identify your specimens. Alternatively, you can use the photographs to track down your insects and then turn to this contents key to find out more about the groups to which they belong.

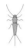

Bristletail Order (Thysanura) p.15

Small, totally wingless, scavenging insects clothed with shiny scales and having three slender filaments at the rear. They live mainly in moss and debris out of doors but some live in houses.

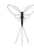

Mayfly Order (Ephemeroptera) pp.16–17

Flimsy insects with minute antennae, one or two pairs of wings, and two or three slender filaments at the rear. The nymphs live in water and the adults, which do not feed, rarely fly far from it.

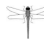

Dragonfly Order (Odonata) pp.18–33

Long-bodied insects with very short antennae, large eyes, and two pairs of wings with an intricate network of veins. The nymphs live in water. Damselflies and demoiselles are slender, weak-flying species that usually pluck small insects from waterside vegetation. They fold their wings together above the body at rest.

True dragonflies are stouter and faster and catch insects in midair. Their wings are spread flat at rest.

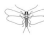

Stonefly Order (Plecoptera) p.34

Soft-bodied, weak-flying, mostly brown insects rarely found far from the water in which the nymphs develop. The wings are folded flat or rolled around the body at rest. Some species have two long filaments at the rear. Adults may nibble algae and pollen, but most do not feed at all.

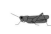

Grasshopper Order (Orthoptera) pp.35–69

Mostly sturdy insects with long hind legs that are normally modified for jumping. There are usually two pairs of wings, folded over the top and sides of the body at rest, but many species are wingless or have very small wings. The pronotum is large and usually saddle-shaped. Female crickets have a blade-like or needle-like ovipositor. Grasshoppers are vegetarians, but many crickets are omnivorous or carnivorous. The males of many species 'sing' by rubbing one part of the body against another.

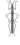

Stick Insects (Order Phasmida) p.70

Slender, green or brown, twig-like leaf-eating insects. The few European species, confined mainly to the south, are wingless.

Earwig Order (Dermaptera) pp.71–72

Small, brownish, omnivorous scavengers with sturdy pincers at the rear. Male pincers are usually strongly curved but female pincers are straighter and more

slender. The forewings, if present, are in the form of
short leathery flaps, leaving the abdomen exposed. The
hindwings, if present, are elaborately folded under the
forewings, but the insects rarely fly. The nymphs
resemble the adults but have very slender pincers.

Cockroach Order (Dictyoptera) pp.73–78

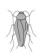

Flattened insects with long, spiky legs. Most have
leathery forewings, laid flat over the body at rest. The
cockroaches are largely nocturnal scavengers, with a
broad, shield-like pronotum covering most of the
head. The order also contains the predatory mantids,
which have an elongate pronotum and enlarged front
legs for grasping other insects. The eggs are always
enclosed in some kind of case. Many mantids lay their
eggs in a mass of foam that hardens into a tough,
fibrous covering.

Bug Order (Hemiptera) pp.79–108

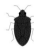

Members of this large order range from tiny aphids
and scale insects to giant water bugs and cicadas. The
only thing they all have in common is a sharp needle-
like beak adapted for piercing and sucking the juices of
plants or other animals. Their wings, if present, may be
leathery or membranous. Members of the sub-order
Heteroptera are commonly confused with beetles, but
are easily distinguished by their beaks and by the
membranous tips of their overlapping forewings.

Lacewing Order (Neuroptera) pp.109–121

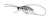

Mostly delicate brown or green insects whose wings,
usually folded roof-like over the body at rest, have a

dense network of veins. Flight is generally weak. Adults and larvae are all basically carnivorous. Many are voracious predators of aphids.

Scorpion Fly Order (Mecoptera) p.122

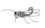

Most members of this small order have rather narrow, spotted wings. The males of most species have an up-turned abdomen reminiscent of that of a scorpion, although the insects are harmless scavengers. The most characteristic feature is the downward extension of the head into a stout beak with jaws at the end.

Beetle Order (Coleoptera) pp.123–185

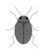

The largest of all the insect orders, with over 20,000 European species. They vary enormously, but generally have horny forewings, called elytra, that meet in a straight line down the middle of the back. The hindwings, if present, are membranous and folded away under the elytra. The pronotum is large and, apart from a small triangular scutellum, is the only part of the thorax visible from above. Beetles have biting jaws and feed on a wide range of plant and animal materials.

Fly Order (Diptera) pp.186–211

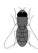

The true flies, ranging from stout bluebottles and horse-flies to leggy crane-flies and tiny midges. Unlike most other insects, they have only two wings. Adult flies all feed on liquids. Some, including the female horse-flies and mosquitoes, have piercing mouth-parts for sucking blood, but most mop up nectar and other free fluids. The larvae are mostly legless maggots.

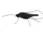

Caddis Fly Order (Trichoptera) pp.212–213

The wings of these mainly brown insects are clothed with tiny hairs. They have few cross-veins and they are folded roof-like over the body at rest, with the antennae held straight out to the front. The larvae live in water, many of them making portable cases from sand and other materials. The adults rarely fly far from water, although they are often attracted to lights at night.

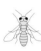

Wasp Order (Hymenoptera) pp.214–251

A very large order, containing the sawflies and a wide range of parasitic insects as well as the bees, wasps and ants. They have very little in common apart from four membranous wings with relatively large cells. The hindwings are much smaller than the forewings and easily overlooked. Apart from the sawflies, the insects have a marked constriction – the so-called wasp-waist – at the front of the abdomen. Sawfly larvae are vegetarian and most of them resemble the caterpillars of butterflies and moths. The larvae of the other hymenopterans are all legless grubs.

Most bees and wasps are solitary insects, each living and fending for itself. Ants, bumble bees, honey bees and some wasps are social insects. They live in colonies ruled by one or more large females called queens, and all work together for the good of the colony. Most of the work is done by small females called workers. Ant and honey bee colonies persist for many years, but wasp and bumble bee colonies survive for just one summer.

Introduction

The insects, with over a million known species, make up the largest of all animal classes. About 100,000 species live in Europe, some 20,000 of them in the British Isles. They occupy almost every habitat, including our homes, and feed on almost every organic material, from solid wood to blood and from nectar to dung. This ability to use almost anything as food has been a major factor in the insects' success. Their small size has also played an important role, enabling them to colonise areas and use foods denied to larger animals.

Only a very small proportion of European insects can be illustrated in this book, but the species selected are mainly the common or conspicuous ones that are likely to come to your notice at home or when on holiday in different parts of Europe. Butterflies and moths are not included as they are covered in *Collins Gem Butterflies & Moths Photoguide*. Fleas, aphids and other tiny insects have also been omitted because they are not easy to identify without a microscope.

The Insect Body

An adult insect can be distinguished from other superficially similar creatures such as spiders and woodlice by its three main body regions – the **head, thorax** and **abdomen** – and its three pairs of legs. Most insects also have **wings**, which are not found in any of these other small animals. The head carries the **mouth-parts**, which vary according to the diet, the **eyes**, and a

pair of **antennae** or feelers. The latter, varying from tiny
bristles to large feather-like structures, are used for
smelling and picking up tactile signals and sometimes for
detecting sounds and heat.

**A typical insect and detached leg, showing the main
anatomical features**

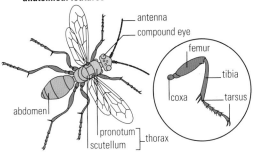

The **pronotum** is a tough plate covering the front
part of the thorax. It is often quite small, but in
grasshoppers, beetles and many bugs it forms a
conspicuous shield. There may also be a prominent
triangular plate called the **scutellum** at the rear of the
thorax. The wings, when present, are always attached to
the thorax. Most wings are membranous and supported
on a network of veins, and the spaces between the veins

are known as **cells**, but beetles and some other insects have tough, horny or leathery forewings, sometimes called **elytra**, that cover and protect the delicate hindwings. At rest, these insects do not look as if they have wings at all.

The legs are also attached to the thorax. They vary in shape according to the habits of the insects, but generally have four main regions. The **coxa** is a short segment attaching the leg to the body. The **femur** is usually quite large and is followed by the **tibia**, which is usually the longest segment of the leg. Beyond the tibia comes the **tarsus** or foot, which consists of up to five short segments and usually ends in a pair of claws. Crickets even have their ears on their front legs.

The abdomen has no limbs, but may have a pair of outgrowths at the rear. These are called **cerci**. They are often hair-like and used like an extra pair of antennae. Silverfish and some mayflies have an additional filament between their cerci. Earwig cerci form sturdy pincers that may be used in fighting. The males of many bush-crickets and some other insects have curved cerci used for grasping the females during mating. Many females have a prominent **ovipositor** or egg-layer projecting from the rear end.

Insect Life Histories

Although some species, including many aphids, give birth to active young, the majority of insects start life as eggs. The young that hatch from the eggs have no wings and

cannot fly. They usually grow very rapidly. Their outer skin is not alive and, although it can stretch a little, it cannot grow. The insect therefore has to change its skin several times as it grows. These skin changes are called **moults**. Most species moult between four and ten times, but some undergo up to 50 moults. During a moult, the outer skin of the insect becomes very thin and brittle and the insect eventually breaks out of it – but not until it has secreted a new, looser coat underneath the old one.

The change from young to adult form is called **metamorphosis** and it follows one of two major pathways. In the first group, typified by the dragonflies and grasshoppers, the young, called **nymphs**, do not look very different from the adults.

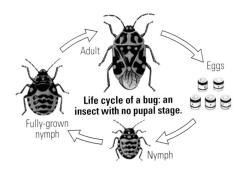

Adult

Eggs

Life cycle of a bug: an insect with no pupal stage.

Fully-grown nymph

Nymph

Their wings develop gradually on the outside of the body, getting larger at each moult until, at the final moult, they reach full size and become functional. This kind of metamorphosis is called partial or incomplete metamorphosis.

In the second group, which includes the lacewings, beetles, flies and wasps, as well as the butterflies and moths, the young do not look anything like the adults. They often lack legs as well as wings and they are called **larvae** or **grubs.** They get larger at each moult, but show no sign of wings. When a larva is fully grown, it moults again, and when the skin is shrugged off this time it reveals a **chrysalis** or **pupa**. This is a non-feeding stage and it rarely moves, but great changes take place inside it as the larval body is broken down and re-built in

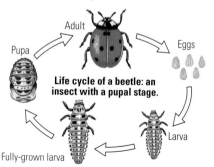

Life cycle of a beetle: an insect with a pupal stage.

Adult

Eggs

Pupa

Larva

Fully-grown larva

the adult form. The outlines of the adult wings and legs can usually be seen on the surface of the pupa. When the changes are complete the adult bursts out of the pupal skin, expands and dries its wings, and flies away. This kind of development is called complete metamorphosis.

Species Entries

English and scientific names are given for most species described in this book, but many of the smaller and less familiar insects have never received English names and the same is true of many non-British species. Only the scientific names can be given for these insects.

Each species has a short text outlining its behaviour and life cycle and pointing out those features that are useful in identifying the species. The sexes are mentioned only if there are major differences between males and females.

SIZE is the average length of the body, including the wings if these are habitually folded along the sides or top of the body as in grasshoppers and crickets, but not including the ovipositor. Wingspans are given for insects that regularly rest with their wings open.

HABITAT is the main type of countryside or surroundings in which the insect is likely to be found.

RANGE is the geographical area in which the species is found. N Europe is Scandinavia and Denmark, and the far N refers to areas above the Arctic Circle. C Europe is

Central Europe, roughly between 45° and 55° N, but including the whole of the British Isles. S Europe is everywhere south of 45°N, which coincides roughly with a line from Bordeaux to the Danube Delta. Remember that an insect does not necessarily occur everywhere within its range: only where the habitat is suitable.

SEASON is the time of year at which the adult insect can be found somewhere in its range, but the season may be much shorter in the north.

SIMILAR SPECIES lists those species with which the insect might be confused and points out the main differences between them.

A fast-running, wingless insect, covered with silvery scales, that lives mainly in houses, especially in dark cupboards and on undisturbed bookshelves. It prefers slightly damp spots and is mainly nocturnal. It feeds on moulds and starchy materials, including book-bindings and the glue of cartons, and can cause serious damage to books and other papers.

SIZE Up to 12 mm.
HABITAT Mainly in houses and other buildings, but often out of doors in S Europe.
RANGE Worldwide.
SEASON All year.
SIMILAR SPECIES The Firebrat is browner with longer antennae and tail filaments.

Ephemera danica

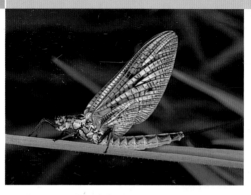

Look for the dark-spotted cream or greyish top of the abdomen to distinguish this insect from several similar species with spotted wings. There are three tail filaments. Like all mayflies, the insects fly mainly by night. The nymphs live in lakes and rivers with plenty of silt or fine sand on the bottom, and take two years to mature.

SIZE 15 mm (without 'tails'): wingspan 30–45 mm.

HABITAT Lakes and rivers and surrounding areas.

RANGE Most of Europe.

SEASON April–September.

SIMILAR SPECIES Other *Ephemera* species have similar wings but brown or yellowish abdomens.

One of several rather similar species with two 'tails' and hindwings in the form of tiny straps. Note the six pale, translucent abdominal segments. The male, shown here, has a turret-like expansion on the top of each eye, although this feature is shared by several related species. The nymphs live in streams and rivers, and in lakes with stony bottoms.

SIZE 5–8 mm (without 'tails'): wingspan 12 mm.
HABITAT Rarely far from the lakes and streams in which the nymphs develop.
RANGE All Europe.
SEASON April–November.
SIMILAR SPECIES *C. pennulatum* is a little larger, with paler eyes and only five pale abdominal segments.

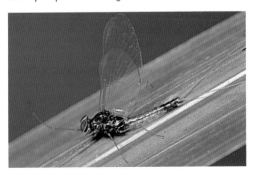

Calopteryx splendens

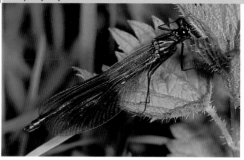

The mature male, shown here, has a brilliant metallic blue body and a dark blue patch on the outer part of each wing. In SW Europe the patches may extend to the wing-tips. The female is metallic green, usually becoming bronze with age, and has yellowish-green wings. The insect prefers slow-moving rivers and canals with muddy bottoms.

SIZE 45 mm: wingspan 60–65 mm.

HABITAT Waterside vegetation.

RANGE Most of Europe except Scotland and most of Scandinavia.

SEASON April–September.

SIMILAR SPECIES Male Beautiful Demoiselle has blue almost to the wing base and female's wings are browner.

The body of this insect is bright green and mature males
develop powdery blue patches. The male also has
prominent claspers at the rear. Look for the elongate black
patch (the pterostigma) near each wing-tip. This species
breeds in still water, including bog pools, with plenty of
fringing vegetation and rests with its wings half open.

SIZE 25–35 mm: wingspan 45–50 mm.
HABITAT Waterside vegetation.
RANGE All Europe except far N and S.
SEASON June–October.
SIMILAR SPECIES Scarce Emerald Damselfly is a little more
robust but impossible to distinguish in the field. Several
continental species are similar but pterostigma is brown.

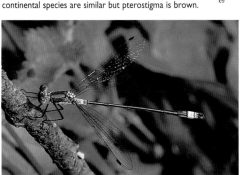

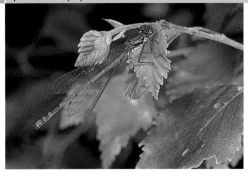

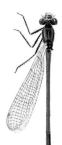

The abdomen is normally bright red with black marks in both sexes, but the male, shown here, usually has less black than the female. The latter has a thin black line down the middle of the abdomen. Both sexes have red stripes on a black thorax, although the stripes are yellowish at first. Look also for the black legs.

SIZE 35–40 mm: wingspan 45–50 mm.
HABITAT Fresh water habitats of all kinds, including peat bogs and muddy ditches; sometimes breeds in brackish water.
RANGE Almost all Europe.
SEASON April–September: one of the earliest species.
SIMILAR SPECIES Small Red Damselfly is smaller, with red legs and no red stripes on the thorax.

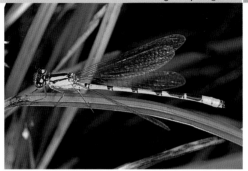

The male, shown here, can be distinguished from other blue and black damselflies by the mushroom-shaped spot, sometimes pointed at the tip, on the second abdominal segment. Look also for the single thin black line on the side of the thorax. The female usually has a green and black abdomen with a prominent spine under the tip. This species breeds in all kinds of fresh water.

SIZE 30–35 mm: wingspan 35–40 mm.
HABITAT Waterside vegetation.
RANGE All Europe.
SEASON May–October.
SIMILAR SPECIES *Coenagrion* males have similar colours but have different abdominal spot patterns and two thin black stripes on each side of the thorax.

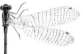

The male, shown here, has a conspicuous blue patch near the tip of the abdomen. In the female the blue is often replaced by lilac or pale brown. The pterostigma (see p.19) near the tip of the forewing is half white and half black, as in all *Ischnura* species. Both sexes have a small spike just behind the head, easily seen with a lens. This species breeds in all kinds of fresh water.

SIZE 25–35 mm: wingspan 30–40 mm.
HABITAT Waterside vegetation.
RANGE Most of Europe except Spain and far N.
SEASON March–October: two or three broods in S.
SIMILAR SPECIES Scarce Blue-tailed Damselfly lacks the spike behind the head.

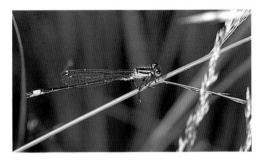

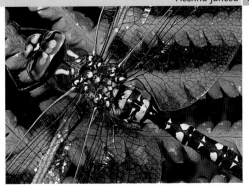

The male, shown here, has narrow yellow stripes on the top of the thorax and paired blue spots on the abdomen. The female has no stripes on top of the thorax and the abdominal spots are yellow or green. Look also for the two yellow stripes on each side of the thorax and the bright yellow vein at the front of each wing. This species breeds in reed-fringed ponds and lakes.

SIZE 70–80 mm: wingspan 90–100 mm.
HABITAT Watersides and open country of all kinds.
RANGE N & C Europe and Iberian mountains.
SEASON June–October.
SIMILAR SPECIES Southern Hawker has broad thoracic stripes in both sexes and a yellow triangle at the front of the abdomen. Hairy Dragonfly has hairy thorax.

Aeshna grandis

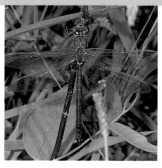

The brown body and brown-veined amber wings distinguish this from all other European dragonflies. Only the male has blue spots on the abdomen. This species breeds in still waters and is most likely to be seen hawking up and down the edges of lakes and canals. The female lowers her abdomen into the water to place her eggs in little slits that she cuts in submerged stems.

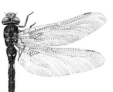

SIZE 65–75 mm: wingspan 100 mm.

HABITAT Lakes and other well-vegetated still waters.

RANGE N & C Europe and a few mountainous areas in S: absent from Scotland.

SEASON June–October.

SIMILAR SPECIES Norfolk Hawker has a brown body but clear wings and green eyes.

The mature male is easily recognised by its
deep blue, black-lined abdomen and
unstriped, greenish thorax. The female has a
greenish-blue abdomen. Look for the
smoothly rounded base of the hindwing in both sexes:
in most hawkers the male's hindwings have sharply angled
bases. This fast-flying species breeds in weedy ponds and
ditches; the female lays her eggs in submerged plants.

SIZE 70–85 mm: wingspan 100–110 mm.
HABITAT Waterside vegetation and open water.
RANGE S & C Europe except Scotland and Ireland.
SEASON May–October.
SIMILAR SPECIES None.

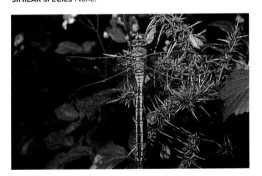

Club-tailed Dragonfly

Gomphus vulgatissimus

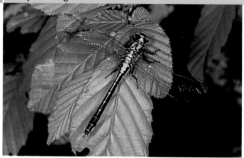

This sturdy insect is easily recognised by the abdomen, which is largely black and markedly swollen or clubbed at the end. Look also for the black legs and the broad yellow stripes at the top of the thorax. The eyes are widely separated. This species breeds mainly in slow-moving rivers, but adults are often seen far from the water.

SIZE 45–55 mm: wingspan 60–70 mm.
HABITAT Waterside vegetation and surrounding areas.
RANGE Mainly N & C Europe except Scotland, Ireland and far N.
SEASON April–August.
SIMILAR SPECIES None in British Isles. Several continental species are similar but more slender and have yellow on their legs.

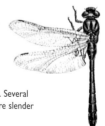

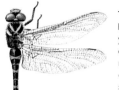

The narrow yellow rings on the black abdomen and the little yellow triangle just behind the eyes make this dragonfly easy to recognise. The sexes are alike except that the male's hindwings are sharply angled at the base and the female's wings are rounded. Look also for the female's spine-like ovipositor, used to lay eggs in the silt. This species breeds in fairly fast streams.

SIZE 70–90 mm: wingspan 95–105 mm.

HABITAT Watersides and surrounding country; most common in upland areas, including moorland.

RANGE All Europe except far N.

SEASON May–September.

SIMILAR SPECIES None in British Isles. *C. bidentata* of S & C Europe lacks the yellow triangle behind the eyes.

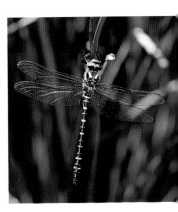

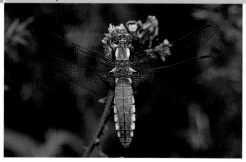

The immature male resembles the female, shown here, but the fully mature male has a powder-blue abdomen except for the yellow marginal spots. Note the dark brown patch at the base of each wing. This species breeds in ponds and other still waters with plenty of vegetation. The adult is a typical darter, hunting from a perch to which it returns after each foray.

SIZE 40–45 mm: wingspan 70–80 mm.

HABITAT Watersides and surrounding countryside.

RANGE All Europe except Scotland, Ireland and far N.

SEASON April–September.

SIMILAR SPECIES Scarce Chaser has no yellow spots and very little brown on the forewing. *Orthetrum* species (p.30) have completely clear wings.

The dark spot in the centre of the front edge of each wing gives this insect its name. The dark smudges near the wing-tips are not always present. Note the amber patch at the base of the forewing and the dark patch at the base of the hindwing. The male never turns blue. This species breeds in shallow ponds and lakes, especially on heaths and moors. It is a great migrant.

SIZE 40–45 mm: wingspan 70–80 mm.
HABITAT Open country of all kinds, but most common on and around bogs and wet heaths.
RANGE All Europe.
SEASON April–September.
SIMILAR SPECIES None.

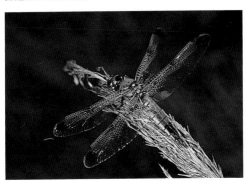

Orthetrum cancellatum

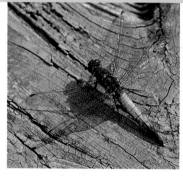

Only the mature male, shown here, normally has blue on the abdomen. Note the black tip of the abdomen. Females and immature males are generally straw-coloured with two rows of curved black streaks on the abdomen. The wings are completely clear in both sexes, with a black pterostigma (see p.19) near the tip. This darter breeds in ponds and lakes, mainly in lowland areas.

SIZE 45–55 mm: wingspan 75–80 mm.
HABITAT Open water and waterside vegetation.
RANGE Most of Europe except Scotland and far N.
SEASON April–August.
SIMILAR SPECIES Most other *Orthetrum* species have brown pterostigma. Broad-bodied Chaser (p.28) and other *Libellula* species have dark wing bases.

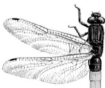

The male, shown here, is the reddest of all the European
dragonflies. Look for the reddish veins at the front of each wing.
The female's body is yellowish-brown, with a row of brighter
yellow marks along the sides of the abdomen. Both sexes have an
amber or yellow patch at the base of each wing. This darter breeds
in shallow, weedy water, including rice paddies.

SIZE 30–45 mm: wingspan 55–65 mm.
HABITAT Waterside vegetation and surrounding areas.
RANGE S & C Europe except British Isles.
SEASON April–November, with two broods in S.
SIMILAR SPECIES None: other red species are more slender and
have black legs.

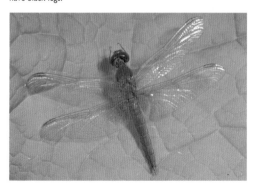

Sympetrum striolatum

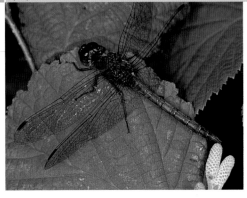

The male, shown here, has a brick-red abdomen, somewhat duller than that of other red darters. Look for the tiny black dots, surrounded by yellow, towards the rear of each abdominal segment. The female is yellowish-brown. There are clear yellow stripes on the legs of both sexes. This species breeds in shallow water, either still or slowly-moving.

SIZE 30–40 mm: wingspan 55–60 mm.
HABITAT Almost anywhere, but most common by water.
RANGE All Europe except far N.
SEASON May–October, but may be all year in S.
SIMILAR SPECIES The males of other red darters are brighter, and both sexes normally have more yellow at the base of the wings.

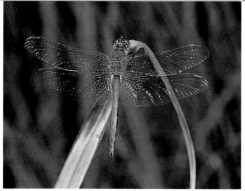

This darter has an extensive yellow flush at the base of each wing. The female, whose abdomen is much browner than that of the male, also has a yellow patch on the front edge of each wing. Look also for the reddish-brown pterostigma (see p.19) and the black outer veins. This species breeds in shallow, weed-filled water, but is a strong migrant and is often found far from water.

SIZE 30–40 mm: wingspan 50–60 mm.
HABITAT Mainly on and near waterside vegetation.
RANGE Most of Europe, but a rare visitor to British Isles.
SEASON June–October.
SIMILAR SPECIES Red-veined Darter usually has less yellow and veins are red (male) or yellow at the base.

One of the largest stoneflies, most likely to be seen resting on waterside rocks or vegetation. Look for the dark thorax and the more or less parallel veins near the wing-tip. The nymphs develop in stony streams, especially with moss-covered boulders. Empty nymphal skins, as shown here with the adult, are common on waterside stones.

SIZE Male 15–20 mm (wingspan 45–55 mm): female 18–25 mm (wingspan 55–70 mm).

HABITAT Stony streams, mainly in upland areas.

RANGE Most of Europe.

SEASON April–August.

SIMILAR SPECIES *Perla bipunctata* has a yellowish body, with a dark central stripe on the thorax. *Perlodes* species have irregular veins at the wing-tips.

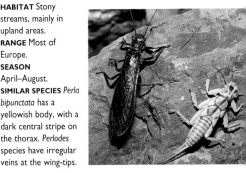

Brown Mountain Grasshopper

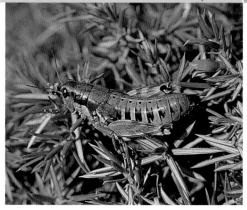

The wings in both sexes are reduced to little brown flaps. Look for the more or less straight rear edge of the pronotum and the blue hind tibiae. The male hops quite well, but the much larger female, shown here, has to drag herself over the ground. There is no song.

SIZE Male 15–20 mm: female 25–30 mm.
HABITAT Dry mountain slopes, especially with sprawling heathers and other low-growing vegetation.
RANGE Most European mountains except in British Isles.
SEASON June–October.
SIMILAR SPECIES Several others live in the far south.

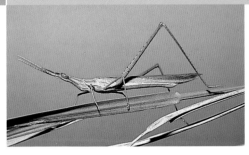

The pointed head and flat, blade-like antennae readily distinguish this slender insect. The male, shown here, is shorter and very much slimmer than the female. The insects are either brown or green and very hard to see in the grass. The female often has brown and white flecks on the forewings. Both sexes fly well. There is no song.

SIZE Male 30–40 mm: female 50–70 mm.

HABITAT Damp grassland, especially near the coast in southern areas.

RANGE S Europe, extending northwards to Austria and Slovakia in the east.

SEASON July–October.

SIMILAR SPECIES None.

Look for the vertically striped eyes and the deeply notched central ridge on the pronotum. The inner surface of the hind femur is pink, while the tibia is bluish-grey with white spines. It feeds on a wide range of plants, especially trees and shrubs, and flies well when disturbed. There is no song. The nymphs are green or orange-brown.

SIZE Male 35–45 mm: female 50–65 mm.
HABITAT Rough vegetation of all kinds.
RANGE Mainly S Europe, sometimes further north, possibly having been carried in produce.
SEASON All year.
SIMILAR SPECIES Migratory Locust (p. 38) is equally large but lacks striped eyes and has a domed thorax. *Decticus albifrons* (p.60) has long antennae.

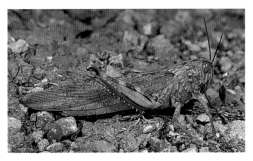

Locusta migratoria

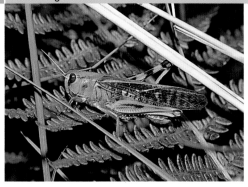

This insect exists in two forms or phases – solitary and gregarious. Most European specimens are of the solitary phase. Look for the domed pronotum, more obvious in the female than in the male, shown here. The gregarious phase forms huge swarms in Africa, but the solitary phase does little damage. The male is often brown and makes a harsh screeching noise when courting.

SIZE Male 30–45 mm: female 50–70 mm.
HABITAT Dense vegetation, including vineyards and other crops, especially in damp areas.
RANGE S & C Europe: a rare visitor to British Isles.
SEASON Mainly June–November: sometimes all year in S.
SIMILAR SPECIES Egyptian Grasshopper (p.37) has striped eyes and a deeply notched but not domed pronotum.

This insect's hindwings are bright blue with a dark brown band near the outer edge. It can be mistaken for a butterfly in flight, but rarely flies far, soon dropping to the ground and 'disappearing'. Its mottled body and forewings range from pale grey to almost black and blend perfectly with the stony ground on which the insect lives. There is no song.

SIZE 15–30 mm.
HABITAT Dry, stony and sandy places with plenty of bare ground.
RANGE Most of Europe except British Isles and far N.
SEASON July–November.
SIMILAR SPECIES *Sphingonotus caerulans* has no dark band on the hindwing. *O. germanica* and several other species have red hindwings.

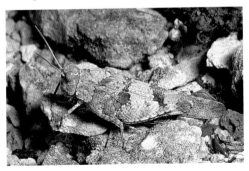

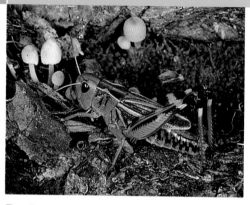

The yellowish male is fully winged and flies well, but the much larger and browner female, shown here, has short wings and cannot fly. Look for the red tibiae of the hind legs, with a yellow ring at the base. The song starts with a few short croaky notes and then becomes a loud rustle for 2–3 seconds before dying away with a few more short notes.

SIZE Male 25–35 mm: female 30–40 mm.
HABITAT Montane grassland and open forest, usually above 1000 m.
RANGE Mainly Alps and Pyrenees.
SEASON July–September.
SIMILAR SPECIES None.

Both sexes are normally shining green. The forewings of the female, shown here, are reduced to very short, widely spaced, pink or golden-green flaps. The male forewings reach more than halfway along the abdomen, but neither sex can fly. The song consists of short buzzing sounds, rather like someone striking matches.

SIZE Male 12–18 mm: female 18–25 mm.
HABITAT Upland grassland, both wet and dry, including stony mountain slopes with little vegetation.
RANGE Upland regions S & C Europe except British Isles.
SEASON June–September.
SIMILAR SPECIES Both sexes of Large Gold Grasshopper have longer wings, those of the male reaching almost to the tip of the abdomen.

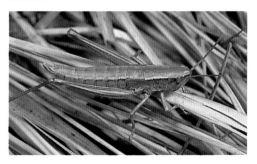

Stripe-winged Grasshopper

Stenobothrus lineatus

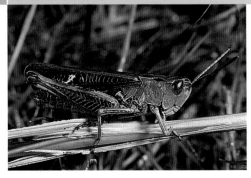

The body is usually green, but the legs and forewings may be brown and the rear of the body is red in the mature insect. Look also for the patch of parallel cross-veins near the middle of the wing. The female has a slender white stripe at the front of the forewing. The song is a rather high-pitched whine, rising and falling in volume and lasting up to 20 seconds.

SIZE 15–25 mm.
HABITAT Dry grassland, especially on lime-rich soils.
RANGE S & C Europe, including southern England.
SEASON June–October.

SIMILAR SPECIES Common Green Grasshopper (p.44) lacks the parallel veins and is never red at the rear.

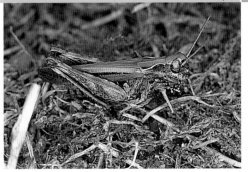

Look for the white-tipped palps under the head. The underside of the abdomen is red or orange when mature. The wings are usually dark brown, although some females are green on top, as seen here. The white-edged ridges at the side of the thorax curve inwards near the front. The hissing song gets louder for 5–10 seconds and then stops abruptly.

SIZE 12–22 mm.

HABITAT Rough grassland, especially woodland margins and clearings: also on heathland.

RANGE Most of Europe but only southern England in British Isles.

SEASON June–October.

SIMILAR SPECIES The white-tipped palps readily distinguish this species from other grasshoppers.

Common Green Grasshopper

Omocestus viridulus

The male is typically green, but may be brown with a little green on the head and pronotum. The female, shown here, is always green above, but may have green, brown or purple sides. The wing-tips are often quite dark, but the tip of the body is never reddish. The ticking or hissing song lasts for 10–20 seconds, getting louder rather like an approaching moped.

SIZE 14–24 mm.
HABITAT Almost any grassland except very dry areas.
RANGE All Europe except far S.
SEASON June–October.
SIMILAR SPECIES Stripe-winged Grasshopper (p.42) has a conspicuous patch of parallel cross-veins in the centre of the forewing.

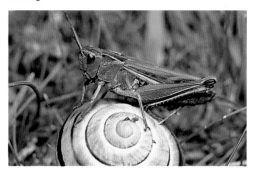

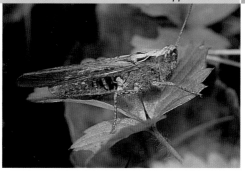

This grasshopper is usually brown, but various parts of the body and wings may be grey, purple, black or green. Look for the very hairy underside, the sharply-angled side ridges on the pronotum, and the small bulge on the front edge of the forewing. The tip of the male abdomen may be red or orange. The song is a series of short chirps resembling time-signal pips.

SIZE 15–25 mm.
HABITAT Dry grassland
of all kinds.
RANGE All Europe.
SEASON June–November.

SIMILAR SPECIES Several are superficially similar, but are less hairy underneath. *C. biguttulus* has a strongly curved front edge to the forewing.

Meadow Grasshopper

Chorthippus parallelus

This species is usually green or brown or a mixture of the two, but females may be purple. Females have very short forewings, (see photo), but the male forewings reach nearly to the tip of the abdomen (see illustration). Hindwings are usually minute in both sexes and the species cannot fly. The side ridges are weak and only gently curved. The song is like short bursts of a sewing machine.

SIZE Male 10–15 mm: female
15–22 mm.
HABITAT All kinds of grassland.
RANGE All Europe.
SEASON June–November.
SIMILAR SPECIES *C. montanus* of bogs and marshes is almost identical but has a very different song.

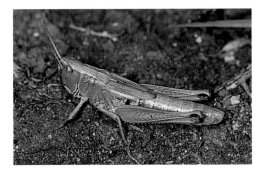

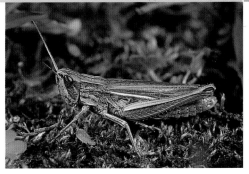

This insect is usually brown or green, or a mixture of the two, and the female, shown here, usually has a white streak on the forewing. Look for the almost parallel, white-edged side ridges or keels of the pronotum in both sexes. The song is a series of 2–6 short chirps, like those of the Field Grasshopper (p.45) but softer and with longer pauses.

SIZE 14–21 mm.
HABITAT Dense grassland, both damp and dry, including coastal dunes and saltmarshes.
RANGE Most of Europe except far S, but absent from northern British Isles.
SEASON July–October.
SIMILAR SPECIES The straight keels of the pronotum separate this from most other grasshoppers.

Large Mountain Grasshopper

Chorthippus scalaris

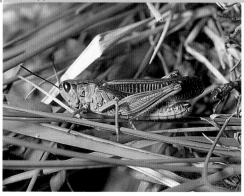

The body is brown or green and all four wings are dark brown.
The male, shown here, has a strongly-arched front edge to the
forewing and a prominent patch of parallel cross-veins in the
centre. The female lacks these features but is otherwise similar.
The loud, rattling song sounds like a free-wheeling bicycle, and the
insects also rustle in flight.

SIZE 20–30 mm.
HABITAT Stony mountain pastures, up to about 2200 m.
RANGE Mountainous areas from S Sweden to the Mediterranean
except British Isles.
SEASON July–September.
SIMILAR SPECIES None.

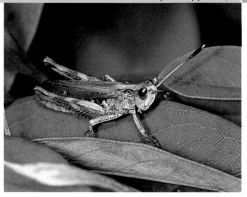

Look for the white-tipped, clubbed antennae, although the female antennae are less strongly clubbed than those of the male, shown here. The body is usually brown, although some females are purple. The male's song is quite quiet and sounds rather like a sewing machine working in bursts of about 5 seconds.

SIZE 14–22 mm.
HABITAT Rough grassland, usually on lime-rich soils.
RANGE All Europe.
SEASON May–November.
SIMILAR SPECIES Mottled Grasshopper (p.51) has no white tips to its swollen antennae.

Gomphocerus sibiricus

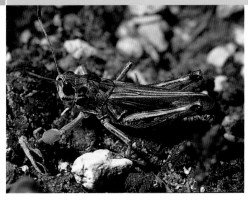

The male, shown here, is easily recognised by his swollen front legs and strongly clubbed antennae. Both sexes have a slightly domed thorax, often with an X-shaped mark on the top. The song starts with a crescendo of several short, well-separated chirps and then turns into a constant hiss that lasts for up to a minute before dying away with a few more short chirps.

SIZE 15–25 mm.
HABITAT Montane grassland.
RANGE Alps, Pyrenees and a few other mountainous areas of southern Europe.
SEASON July–September.
SIMILAR SPECIES None.

This rather dark but very variable grasshopper can be distinguished from other common species by its small size and by the swollen tips of the antennae, although the thickening is much less obvious in the female than in the male, shown here. There is usually an X-shaped mark on the top of the thorax. The male's song sounds rather like a clock being wound, with 10–30 short chirps increasing in volume over a few seconds.

SIZE 10–20 mm.
HABITAT Heaths and other dry, grassy places.
RANGE All Europe.
SEASON June–October.
SIMILAR SPECIES Rufous Grasshopper (p.49) has white-tipped antennae.

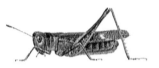

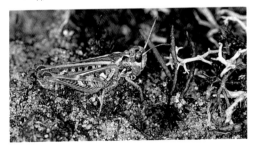

Meconema thalassinum

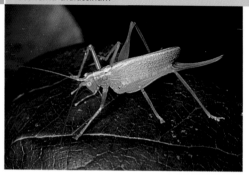

This fully-winged, insect-eating species often comes to lights at night. Look for the yellow or brownish stripe along the back, flanked by two brown patches on the thorax. The gently curved ovipositor of the female, shown here, extends well beyond the wings. The male has long, slender claspers. There is no song and the male attracts a mate by tapping leaves with his feet.

SIZE Male 13–17 mm: ovipositor 9 mm.
HABITAT Deciduous woods and trees of many kinds: often common in gardens and orchards.
RANGE All Europe except Scotland and far N.
SEASON July–November.
SIMILAR SPECIES None.

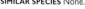

Look for the rounded side lobes of the pronotum and the long hindwings, projecting way beyond the forewings. The male, shown here, has curved claspers and the female has a short and strongly curved ovipositor. The insect feeds on a wide range of plants and flies well when disturbed. The high-pitched, ticking song is produced mainly at night.

SIZE 20–30 mm: ovipositor 5 mm.
HABITAT Nettle-beds, brambles and other dense vegetation.
RANGE S & C Europe except British Isles.
SEASON July–October.
SIMILAR SPECIES *P. nana* of the Mediterranean region is very similar. *Tylopsis liliifolia* has a more rectangular pronotum.

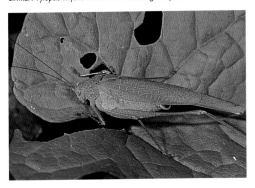

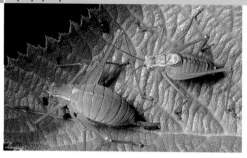

This insect is covered with tiny dark dots. There is a narrow brown stripe on the back, but this may be very faint in the female, seen on the left. Flap-like brown or green forewings, larger in males than in females, lie just behind the pronotum. The female has a short, broad ovipositor. The insect is largely vegetarian. The song is a barely-audible scratching sound.

SIZE 10–18 mm: ovipositor 6–8 mm.
HABITAT Dense vegetation of all kinds, including nettle-beds, brambles and garden borders.
RANGE All Europe except far N, but rarely found in northern British Isles.
SEASON July–November.
SIMILAR SPECIES Several similar but fairly rare species live in southern Europe.

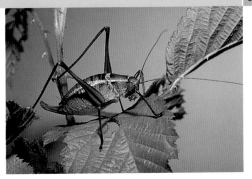

Males are usually much browner than the female shown here. Note the teeth on the ovipositor. The wings are reduced to small flaps just behind the pronotum, those of the male being inflated in connection with sound-production. The song, produced mainly at night, is a sequence of feeble grinding sounds. The insect is mainly vegetarian.

SIZE 15–20 mm: ovipositor 10 mm.
HABITAT Shrubby places, including vineyards where it sometimes causes considerable damage.
RANGE SW Europe.
SEASON May–August.
SIMILAR SPECIES *B. constrictus* of E Europe is very similar. *B. serricauda* of C Europe is a little smaller and greener.

Ruspolia nitidula

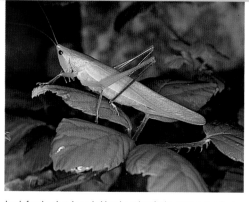

Look for the sharply-angled head to identify this omnivorous bush-cricket. It is usually pale green, but flesh-coloured and yellowish individuals are not uncommon. The elytra and hindwings are about the same length and the female, shown here, has a straight ovipositor almost as long as her body. The song, emitted continuously for long periods at night, sounds like a knife-grinder.

SIZE 40–55 mm: ovipositor 17–25 mm.
HABITAT Dense vegetation, including reed beds and hedgerows: most common in damp areas.
RANGE S & C Europe.
SEASON July–October.
SIMILAR SPECIES None.

This bush-cricket is normally green with long, golden-brown forewings and a brown streak on the head and pronotum, but some individuals are all brown.

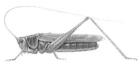

Active mainly by day, it feeds on grasses and small insects. The female has a long, almost straight, ovipositor. The song comes in long bursts, sounding rather like a distant knife-grinder.

SIZE 15–22 mm: ovipositor 9 mm.
HABITAT Tall grass and rough vegetation, wet or dry.
RANGE All Europe except far N, but only in a few places near the S coast in British Isles.
SEASON July–November.
SIMILAR SPECIES Short-winged Conehead usually has short wings and female has a strongly curved ovipositor.

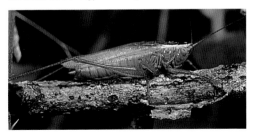

Great Green Bush-cricket

Tettigonia viridissima

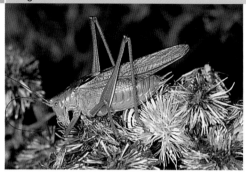

Easily recognised by its size and by the brown stripe on the head and thorax. The female's slightly down-curved ovipositor just reaches the wing-tips. The insect can fly well, but spends most of its time in dense vegetation, eating plant matter and other insects. Listen for the loud song, rather like a sewing machine, in the late afternoon and evening.

SIZE 40–55 mm: ovipositor 18–25 mm.

HABITAT Nettle-beds, shrubs and other rough places.

RANGE Most of Europe except in far N, Scotland and Ireland.

SEASON June–November.

SIMILAR SPECIES

Tettigonia cantans has shorter, more rounded wings.

This bush-cricket is green or brown, although the brown form does not occur in the British Isles. People in Sweden once used its powerful jaws to bite off their warts. It eats both plants and other insects, including grasshoppers. The female's long ovipositor curves gently upwards. Listen for the male's song on sunny days. It goes on for long periods and sounds a bit like a free-wheeling bicycle.

SIZE 30–40 mm: ovipositor 20 mm.
HABITAT Rough grassland, heaths and marshes.
RANGE Most of Europe, but in British Isles it is confined to a few sites in southern England.
SEASON July–October.
SIMILAR SPECIES None.

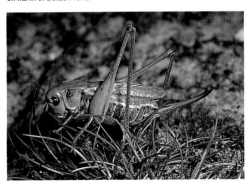

Look for the very pale face. The female's long, almost straight, ovipositor may extend well beyond the wings. It eats both plant and animal material and is sometimes a pest of cereals and fruit crops. It is active mainly by day. The male's shrill, chirpy song, produced only when the temperature exceeds 23°C, sounds more like a bird than an insect.

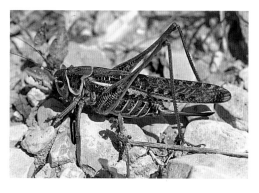

SIZE 50–60 mm: ovipositor 20–25 mm.
HABITAT Rough grassland and light woodland.
RANGE S Europe.
SEASON July–November.
SIMILAR SPECIES Egyptian Grasshopper (p.37) and Migratory Locust (p.38) are superficially similar but have short antennae.

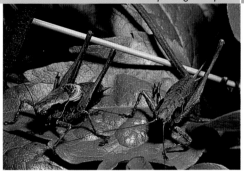

This omnivorous insect ranges from pale to dark brown, with a greenish-yellow underside. The forewings of the male, seen on the left, form a little 'saddle' just behind the pronotum: the female, on the right, is virtually wingless. The song, heard mainly in the evening, is an irregular sequence of short chirps – *psst–psst–psst*.

SIZE 13–20 mm: ovipositor 10 mm.
HABITAT Nettle-beds and other rough vegetation, where both sexes can be seen basking on the leaves.
RANGE All Europe, but rare in Scotland and Ireland.
SEASON June–November – one of the last to die off in the autumn.
SIMILAR SPECIES Alpine Dark Bush-cricket has a pale edging on the sides of the pronotum.

This bush-cricket is one of Europe's largest insects. The female, shown here, is wingless, but the male has small flaps. Look for the smooth face and *narrow* cream or yellow border to the pronotum. The female's ovipositor is usually less than three times as long as the pronotum. *Saga* feeds on grasshoppers and other insects and its jaws can inflict a painful bite.

SIZE 45–80 mm: ovipositor 25–35 mm.
HABITAT Rough ground with low-growing bushes.
RANGE SE Europe.
SEASON June–September.
SIMILAR SPECIES *S. pedo*, of which only females are known, has an ovipositor generally more than three times as long as the pronotum.

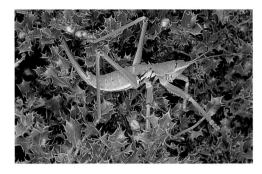

Saddle-backed Bush-cricket

This mainly vegetarian insect is green or brown. Look for the strongly raised rear half of the pronotum, typical of all *Ephippiger* species. The forewings are reduced to small yellow flaps partly concealed by the pronotum. The song is a rasping double chirp, giving the insect its French name of *tizi*. It is produced by both sexes and heard mainly by day.

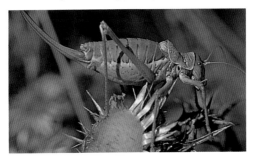

SIZE 20–30 mm: ovipositor 20–25 mm.
HABITAT Hedgerows and other bushy places: sometimes damages vines.
RANGE S & C Europe except British Isles.
SEASON July–October.
SIMILAR SPECIES Several live in S Europe: *E. provincialis* of S France is brown and up to 80 mm long (including the ovipositor).

Acheta domesticus

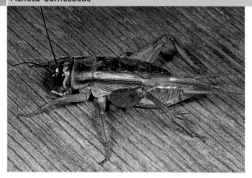

Look for the rolled-up hindwings, projecting beyond the body between the two cerci. The male, shown here, appears to have four tails. The female, with her long, slender ovipositor, appears to have five tails. A native of North Africa, this omnivorous insect now lives all over the world. It flies well and emits its shrill, whistle-like song at night.

SIZE 15–20 mm: ovipositor 8–13 mm.

HABITAT Heated buildings, especially in and around kitchens, and rubbish dumps: may move into the surrounding countryside in hot summers.

RANGE All Europe.

SEASON All year in warm conditions.

SIMILAR SPECIES *Eugryllodes pipiens* lacks projecting hindwings.

Size and colour separate this from most other crickets. The yellow patch may be absent, but look for a red patch under the hind legs. The female has a spear-like ovipositor. The insects cannot fly. They live in burrows and are mainly vegetarian. The male sings his bird-like song at his burrow entrance by day and night.

SIZE 17–25 mm: ovipositor 8–12 mm.
HABITAT Grassy places of all kinds.
RANGE Most of Europe except far N, but almost extinct in British Isles.
SEASON April–August: winter is passed as a nymph.
SIMILAR SPECIES *G. bimaculatus* of the Mediterranean area is fully winged, with the rolled hindwings projecting beyond the body.

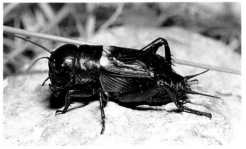

Look for the pale cross on the pronotum to identify this wingless and silent cricket. The brown spots vary in extent and some specimens are dark all over. The sexes are alike except that the female, shown here, has a long and slightly down-curved ovipositor. The insect is omnivorous and active mainly at night.

SIZE 15–18 mm: ovipositor 12–15 mm.
HABITAT Damp, rocky places, including old walls and buildings: often in cellars.
RANGE S Europe.
SEASON Mainly September–December.
SIMILAR SPECIES *G. uclensis* is smaller and female has a straight ovipositor.

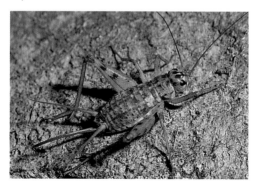

The female, shown here, has very short, diverging forewings. The male forewings reach about halfway along the abdomen. This flightless ground-dweller feeds mainly on dead leaves and their associated fungi. It is very agile and leaps remarkably well. The soft, purring song is produced by day and night but is not easily heard.

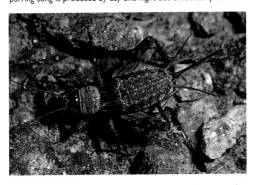

SIZE 7–11 mm: ovipositor 6 mm.
HABITAT Edges and clearings of deciduous woods, usually in deep leaf litter.
RANGE S & C Europe, but only in a few southern counties in British Isles.
SEASON June–November.
SIMILAR SPECIES Marsh Cricket of damp grassland is a little smaller and often fully winged.

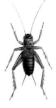

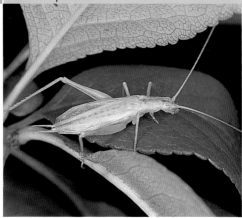

This slender cricket is more likely to be heard than seen. The male, shown here, raises its flimsy, transparent wings at dusk and emits a soft, bubbling call of *grii–grii–grii* to attract a female. The latter has narrower wings and a long ovipositor. The insects feed on a wide range of plants.

SIZE 10–15 mm: ovipositor 7 mm.
HABITAT Trees, bushes and tall herbage.
RANGE S & C Europe except British Isles.
SEASON July–October.
SIMILAR SPECIES None.

This insect spends most of its time tunnelling in the soil with its powerful front legs. The forewings are short, but the hindwings are fully developed and the cricket flies on warm evenings. Males produce purring songs at their burrow entrances. Mole crickets feed mainly on other animals, but also chew roots and cause considerable damage to crops in southern Europe.

SIZE 35–45 mm: no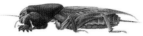
ovipositor.
HABITAT Grassland,
heathland and cultivated land – as long as the soil is damp.
RANGE Most of Europe, but very rare in British Isles.
SEASON All year, but dormant in winter.
SIMILAR SPECIES *G. vineae* from S Europe is similar but has a much louder song.

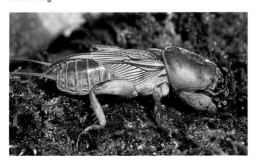

Stick Insect

70 *Clonopsis gallica*

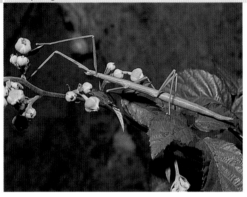

This green or brown, twig-like insect feeds on a wide range of shrubs at night. The antennae are about as long as the head and have 12 or 13 segments. Almost all specimens are females, which lay fertile eggs without mating. The seed-like eggs are dropped to the ground and usually hatch the following spring.

SIZE Up to about 80 mm.
HABITAT Hedgerows, gardens and other bushy areas.
RANGE S Europe.
SEASON May–October.
SIMILAR SPECIES The antennae of *Bacillus rossius* are much longer than the head. *Leptynia hispanica* is smaller and the antennae usually have only 11 segments.

This earwig varies from sandy-grey to reddish-brown. The last abdominal segment is wider than the rest. Look for the gently curving pincers of the male, shown here. The female pincers are almost straight and may cross at the tip. The insect burrows in sand and debris by day and scavenges for food, including small insects, at night. Both sexes are fully winged but rarely fly.

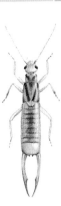

SIZE Up to 25 mm: the largest European earwig.
HABITAT Mainly on seashores and river banks, but also on rubbish dumps and in some seaside towns.
RANGE Mostly S Europe: probably extinct in British Isles.
SEASON All year.
SIMILAR SPECIES None.

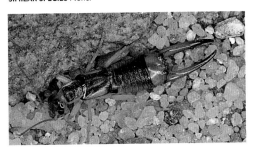

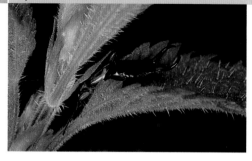

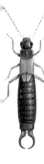

Look for the tips of the hindwings projecting as pale triangles beyond the leathery forewings or elytra. The male, shown here, has strongly curved pincers with a broad, flat base, often much longer than seen here. The female pincers are more slender and almost straight. Both sexes can fly, but rarely do so. The insects are primarily vegetarians.

SIZE 10–15 mm.

HABITAT Almost anywhere, including gardens and houses.

RANGE All Europe: the only earwig commonly seen in British Isles.

SEASON All year, although usually dormant in the ground in winter.

SIMILAR SPECIES Small Earwig is much smaller. Few others have projecting hindwings.

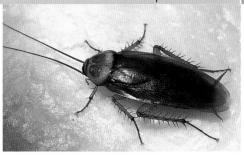

This fast-running omnivorous insect originally came from Africa, but now lives as a scavenger in buildings all over the world. It is also common on ships and is sometimes called the ship cockroach. It flies well in warm conditions. Males are a little larger than females.

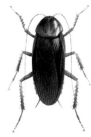

SIZE 25–45 mm.
HABITAT Heated buildings, including greenhouses, and also in coal mines and sewers. Rarely seen in the open in Europe.
RANGE All Europe in suitable buildings.
SEASON All year.
SIMILAR SPECIES Australian Cockroach is a little smaller and has a yellow margin to the pronotum.

Common Cockroach

Blatta orientalis

The forewings of the male cover most of the abdomen, but those of the female, seen here, are reduced to tiny flaps just behind the pronotum. Neither sex can fly, but they are fast and agile runners. Also known as the black beetle and the oriental cockroach, the insect originally came from North Africa or Asia. It lives as a scavenger in buildings and also on rubbish dumps.

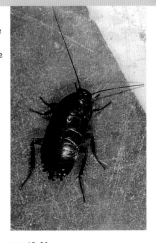

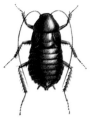

SIZE 15–30 mm.
HABITAT Heated buildings, including greenhouses, and also in coal mines and sewers.
RANGE All Europe in suitable buildings.
SEASON All year.
SIMILAR SPECIES None.

Look for the two dark stripes on the pronotum. Both sexes are fully winged and can fly well, although they prefer to scuttle over the ground. Despite its name, the insect probably originated in eastern Asia, but it now lives as a scavenger in buildings all over the world. The female carries her purse-like egg-case for several weeks, projecting from the end of her abdomen.

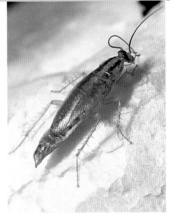

SIZE 10–15 mm.
HABITAT Heated buildings and rubbish tips.
RANGE All Europe in suitable buildings.
SEASON All year.
SIMILAR SPECIES Several others live in S Europe but lack the dark stripes on the pronotum.

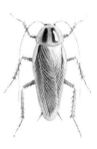

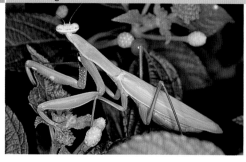

This brown or green insect is named for the way in which it holds its spiky front legs in front of its face – as if praying. When prey comes within reach, the legs shoot out and grab it. The mantis eats grasshoppers and many other insects. The female, shown here, is stouter than the male and often eats him while mating. The eggs pass the winter in horny cases and hatch in the spring.

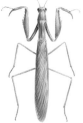

SIZE Up to 75 mm.
HABITAT Rough grassy and bushy places.
RANGE S & C Europe except British Isles.
SEASON July–November, flying readily in warm weather.
SIMILAR SPECIES *Empusa fasciata* (p.78) has a more slender neck. *Iris oratoria* has coloured hindwings.

This little brown mantis scuttles over vegetation in search of small flies and other insects. The male is fully winged and can fly, but the female has only small flaps. Look for the rounded eyes and the smooth margins of the neck (pronotum), which is widest in the middle. The eggs pass the winter in little triangular packets and hatch in the spring.

SIZE 20–25 mm.
HABITAT Warm, dry grassland and bushy places.
RANGE S Europe.
SEASON July–September.
SIMILAR SPECIES *A. spallanzania* has pointed eyes and the female abdomen is short and fat. *Geomantis larvoides* is totally wingless.

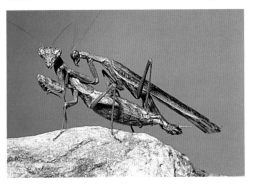

Empusa fasciata

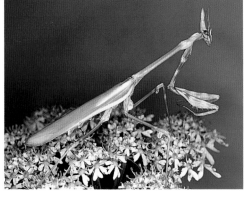

Look for the long, slender 'neck', the crest on top of the head, and the flaps under the abdomen to distinguish this green or brown insect from the Praying Mantis (p.76). It feeds on small flies. Winter is spent as a nymph, which is brown and rests in an upright position with its abdomen curved forward over its thorax. Adults fly well and males often come to lights at night.

SIZE 45–70 mm.
HABITAT Rough grassy and bushy places.
RANGE SE Europe.
SEASON May–September.
SIMILAR SPECIES *E. pennata* of SW Europe has narrower flaps at the base of its middle and hind legs.

Pied Shield Bug

Sehirus bicolor

Easily identified by its colour, this bug feeds mainly on white deadnettle. Adults hibernate in the soil or in moss and leaf litter. They fly well and can be found on a wide range of shrubs and herbaceous plants when dispersing after hibernation. The nymphs are cream with black spots and are often mistaken for ladybirds. They feed mainly on the deadnettle flowers and fruits.

SIZE 7–10 mm.
HABITAT Roadsides and waste ground, wherever deadnettles grow. Black horehound is also eaten.
RANGE All Europe except Scotland and far N.
SEASON All year, but dormant in winter.
SIMILAR SPECIES *S. sexmaculatus* has a blue or greenish sheen and longer white streaks on the pronotum.

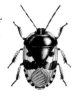

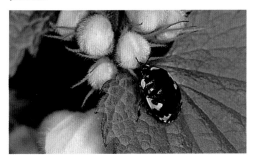

Hawthorn Shield Bug

Acanthosoma haemorrhoidale

Look for the distinctly triangular shape and the bright green scutellum or shield. The latter is surrounded by a bold red triangle formed by the forewings and the rear of the pronotum. Note also the sharply pointed sides of the pronotum. The bug feeds on various trees but mainly on the leaves and fruits of hawthorn. The adults hibernate in moss and leaf litter.

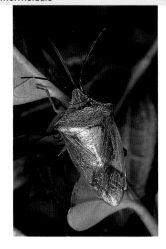

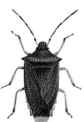

SIZE 15 mm.

HABITAT Deciduous woods and hedgerows.

RANGE Most of Europe except far N.

SEASON All year, but most often seen in autumn.

SIMILAR SPECIES Birch Shield Bug has a similar pattern but is only 8–10 mm long. Juniper Shield Bug has much less pointed sides to the pronotum.

This shield bug can be mistaken for a ladybird because of the orange or red ground colour, but ladybirds do not have membranous wing-tips. The dark spots are black or metallic green. The pattern varies, but look for the four spots near the rear edge of the pronotum. A common pest of cabbages and other brassica crops on the continent. Adults pass the winter in leaf litter.

SIZE 6–10 mm.
HABITAT Cultivated and waste ground, feeding on wild and cultivated members of the cabbage family.
RANGE Most of Europe, but rare in British Isles (S only).
SEASON All year, but dormant in winter.
SIMILAR SPECIES Many other bugs have similar colours, but are generally less rounded.

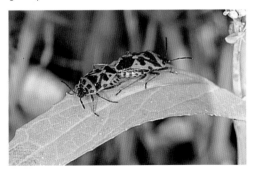

European Tortoise Bug

82 *Eurygaster maura*

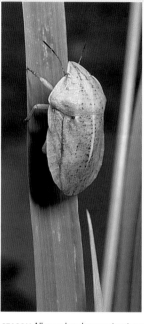

The colour of this beetle-like bug ranges from pale to dark brown, with or without the central white line. Look for the large, parallel-sided scutellum that covers most of the body to distinguish it from most other bugs. It feeds on various grasses and sometimes damages wheat and other cereals on the continent. Adults hibernate in dense vegetation.

SIZE 8–10 mm.
HABITAT Rough, dry grassland and cereal fields.
RANGE S & C Europe, but in the British Isles it is found only in the southern half of England.
SEASON All year, but dormant in winter.
SIMILAR SPECIES *E. testudinaria* is almost identical, but often darker and found in damper areas.

Bishop's Mitre

Aelia acuminata 83

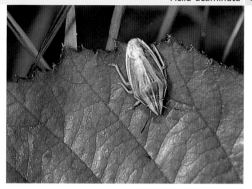

Named for its rather pointed shape, this bug is easy to recognise. Look for the three ridges or keels on the pronotum and the very smooth, shiny edges of the forewings. It feeds on grasses, mainly on the grain, and is sometimes a pest of cultivated cereals on the continent.

SIZE 10 mm.

HABITAT Rough grassland, including roadside verges and sand dunes, and also cereal fields.

RANGE Most of Europe except northern British Isles and far N.

SEASON All year, but dormant in winter.

SIMILAR SPECIES *A. glebana* of S & C Europe (not British Isles) is more robust and about 12 mm long. European Tortoise Bug (opposite) has a longer scutellum.

Graphosoma italicum

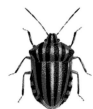

The pronotum of this shield bug covers almost all of the abdomen. The bold colours advertise the fact that it has an awful taste, and very few birds or other predators are likely to try it more than once. It is most likely to be seen feeding on members of the carrot family. It is sometimes so numerous on the flowerheads that they look red from a distance.

SIZE Up to 10 mm.
HABITAT Roadsides and any other rough ground with umbellifers.
RANGE S & C Europe except British Isles.
SEASON June–October.
SIMILAR SPECIES *G. semipunctatum* has rows of black dots just behind its head instead of stripes: its legs are also redder.

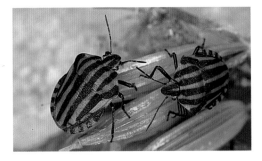

Look for the almost rectangular pronotum, with broad, square 'shoulders' and a little point on each side. The pale spot at the tip of the scutellum is often orange. The bug lives on a wide range of trees, feeding on sap and sometimes damaging fruit. It also eats small caterpillars and other insects.

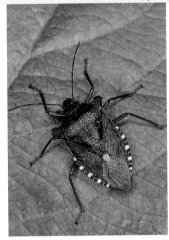

SIZE 15 mm.
HABITAT Deciduous woods, orchards and hedgerows.
RANGE Most of Europe.
SEASON June–October.
SIMILAR SPECIES Several others have similar colours but lack the square 'shoulders'. *Picromerus bidens* (p.86) has a strong spine on each side of the pronotum.

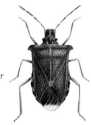

Picromerus bidens

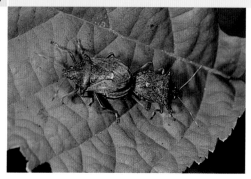

The edges of the pronotum slope sharply back from the head and then expand to form a stout spine on each side. The insect feeds on caterpillars and other soft-bodied insects, including Colorado Beetle grubs, although it is not abundant enough to control this pest. Winter is passed as an egg.

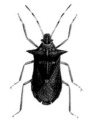

SIZE 10 mm.
HABITAT Hedgerows and other dense vegetation, especially in damp places.
RANGE Most of Europe.
SEASON July–October.
SIMILAR SPECIES *P. nigridens* of S Europe has more black on the antennae. Forest Bug (p.85) has square 'shoulders' and no stout spines.

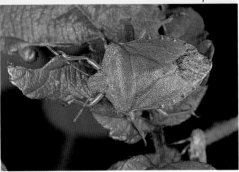

Bright green, as shown here, in the summer, this bug becomes
bronze before going into hibernation in the autumn and becomes
bright green again in the spring. Look for the *slightly* concave edges
of the pronotum. The wing-tip membrane ranges from pale brown
to almost black. The bug feeds on a wide range of trees, shrubs
and herbaceous plants.

SIZE 14 mm.
HABITAT Hedgerows, deciduous woods and almost any other area
of dense vegetation.
RANGE Most of Europe.
SEASON All year, but dormant in winter.
SIMILAR SPECIES *P. viridissima* has slightly convex sides to the
pronotum. Adult *Nezara viridula* (p.88) has a greener and clearer
wing-tip membrane.

The colourful nymph, shown here, is often abundant and very conspicuous in the autumn on vegetation, including cultivated peas and potatoes. The adult is usually leaf green, with a clear greenish membrane at the wing-tip. There is a line of three to five small white dots across the thorax. The head and the front part of the thorax are sometimes pale brown.

SIZE 10–15 mm (adult).
HABITAT Any well-vegetated habitat, including gardens.
RANGE S & C Europe except British Isles.
SEASON All year, but usually dormant in winter.
SIMILAR SPECIES Nymph is unmistakable. Adult Green Shield Bug (p.87) lacks the white dots on the thorax and has a darker membrane.

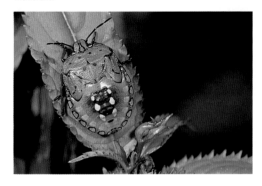

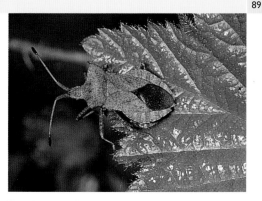

The colour ranges from chestnut-brown to a very dark brown.
Use a lens to look for two tiny horns between the antennae. The
latter have only four segments, not five as in the shield bugs. The
nymphs feed on docks and related plants, but the adult bugs occur
on a wide range of shrubs and herbaceous plants, feeding mainly
on fruits and seeds. They hibernate in leaf litter.

SIZE 12 mm.
HABITAT Hedgerows, woodland margins and
almost anywhere else with dense vegetation.
RANGE All Europe except Scotland and far N.
SEASON All year, but dormant in winter.
SIMILAR SPECIES There are many on the
continent.

Fire Bug

90 *Pyrrhocoris apterus*

The forewings are usually short, but fully-winged insects are occasionally found. Look for the completely black head and conspicuous round black spot on each forewing to distinguish this species. It feeds mainly on seeds but also attacks other insects. Adults hibernate in the soil and large swarms can be found on the ground in early spring.

SIZE 10 mm.

HABITAT Woods and most other well-vegetated places.

RANGE S & C Europe, including southern England.

SEASON All year, but usually dormant in winter.

SIMILAR SPECIES Several bugs have similar colours but usually have red heads and fully-developed wings.

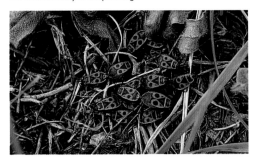

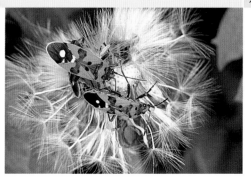

Look for the red head and the white spots on the membranous
wing-tip to distinguish this from several superficially similar red
and black bugs. It feeds on a wide range of herbaceous plants,
mainly on the flowers and developing fruits and seeds, and
sometimes damages cauliflowers. It is often seen feeding on seeds
on the ground in the spring.

SIZE 12 mm.
HABITAT Rough vegetation of all kinds, especially in warm, dry
places.
RANGE Most of Europe except British Isles and far N.
SEASON All year, but dormant in winter.
SIMILAR SPECIES *L. saxatilis* has no white on the wing membrane.
Tropidothorax leucopterus has a black head and a ridge on the
pronotum.

Red Assassin Bug

92 *Rhinocoris iracundus*

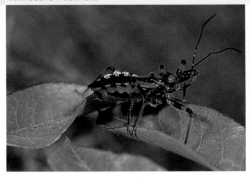

Look for the narrow head and the up-turned sides of the abdomen. The red and black pattern is variable. This predatory bug feeds on a wide range of other insects, including bees, which it usually grabs while sitting in flowers. The powerful, curved beak, clearly seen here, stabs the victims and sucks out their juices. It can also pierce fingers if the bug is roughly handled.

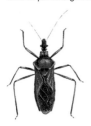

SIZE 14–18 mm.
HABITAT Shrubs and other tall vegetation, mainly in warm, sunny areas.
RANGE S & C Europe except British Isles.
SEASON May–September.
SIMILAR SPECIES The first segment of the beak of *R. erythropus* is black.

Common Flower Bug

Anthocoris nemorum

The shiny forewings distinguish this common bug from several similar species. Look for the black spot near the middle of each forewing and note the lack of veins in the membrane. Despite its name, this bug occurs mainly on leaves. It feeds on aphids and other small insects and mites. It has a surprisingly powerful beak and can easily pierce human skin.

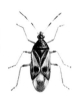

SIZE 3–5 mm.
HABITAT All kinds of vegetation, including tree trunks: especially common on stinging nettles.
RANGE All Europe.
SEASON All year, but dormant in winter – commonly in grass tufts or under loose bark.
SIMILAR SPECIES Several bugs are superficially similar, but differ in pattern.

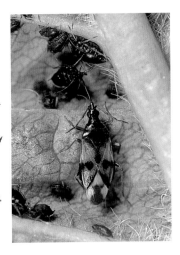

Lygus rugulipennis

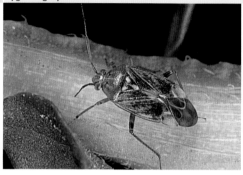

This very common bug is named for the rust-coloured 'stain' on the forewings. The latter are rather downy, with a pale yellow patch in front of the membrane on each side. The bug feeds on a wide range of plants and can be a pest of potatoes and wheat. It causes white spots on the leaves. There are up to three broods in a year. Adults hibernate in leaf litter and other debris.

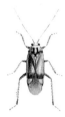

SIZE 5 mm.
HABITAT Any well-vegetated area, including gardens.
RANGE Most of Europe.
SEASON All year, but dormant in winter. Most common in late summer and autumn.
SIMILAR SPECIES *L. pratensis* has similar colours but is not downy.

Common Green Capsid

Lygocoris pabulus

Look for the pale brown spines on the legs and the narrow 'collar' at the front of the pronotum. This very common bug feeds on a wide range of woody and herbaceous plants and is often a pest of soft fruit. There are two broods each year. Eggs are laid on the twigs of various trees and shrubs in the autumn and hatch in the spring.

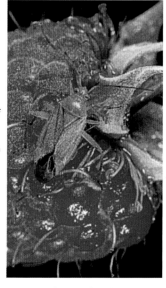

SIZE 7 mm.
HABITAT Any well-vegetated area.
RANGE All Europe.
SEASON
May–October.
SIMILAR SPECIES There are many other green bugs, but if they have a 'collar' their leg spines, if present, are not pale brown. The Potato Capsid has two black spots on the pronotum.

Calocoris quadripunctatus

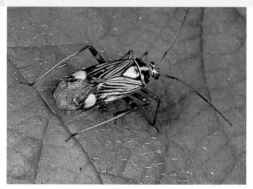

Look for the boldly-striped forewings and the black-tipped pale triangle on each side just in front of the membrane. The pale markings are sometimes light orange. The bug is very common on oak trees, where the youngsters feed on the catkins. The adult bugs feed mainly on other small insects. Winter is passed as eggs inside the oak buds.

SIZE 7–9 mm.
HABITAT Woods, parks and hedgerows, wherever oaks grow.
RANGE Most of Europe except far N.
SEASON May–September.
SIMILAR SPECIES *Miris striatus* has a similar pattern but is longer and slimmer and the pale patch in front of the membrane is orange or red without a black tip.

This bug is usually seen skimming over the surface of still and slow-moving water. Little dimples show where its legs rest on the surface film. The front legs are used to grab other insects falling on to the water surface. The bug seen here is fully winged, but most individuals have short wings or none at all. The adults hibernate in debris on land, sometimes far from the water.

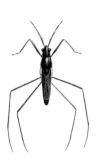

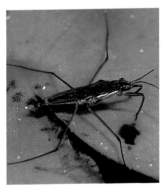

SIZE 10–12 mm.
HABITAT Ponds, ditches and quiet backwaters.
RANGE All Europe.
SEASON All year, but dormant in winter.
SIMILAR SPECIES There are several similar bugs. *Aquarius najas* is larger and wingless and prefers slightly faster streams.

Water Scorpion

Nepa cinerea

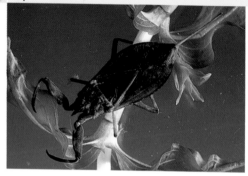

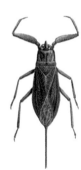

Despite its name and grotesque appearance, this very flat bug is quite harmless. The spine at the rear is simply a breathing tube through which the insect draws air from the surface. The bug creeps slowly over the mud and vegetation in shallow water and catches prey, including tadpoles and small fishes, with its sturdy front legs. Although fully winged, it rarely flies.

SIZE 20–35 mm (including the breathing tube).
HABITAT Shallow, still or slow-moving water.
RANGE All Europe.
SEASON All year.
SIMILAR SPECIES None. Water Stick Insect is a longer and more slender relative.

Common Backswimmer

Notonecta glauca 99

This water bug swims on its back, using its long back legs like oars. The forewings are silvery-grey. The belly also looks silvery because it carries a bubble of air. The bug surfaces tail-first to renew its air supply. It eats tadpoles, small fishes and other small animals. It is often called the greater water boatman, but true water boatmen (p.100) swim right-way-up.

SIZE 15 mm.
HABITAT Still and slow-moving water, but the bug flies well and is often found far from water.
RANGE All Europe.
SEASON All year.
SIMILAR SPECIES *N. maculata* has mottled, brick-coloured forewings.

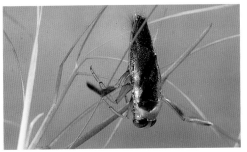

100 *Sigara dorsalis*

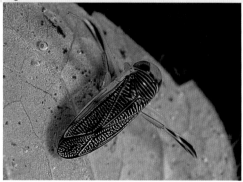

This water bug swims right-way-up and the middle and hind legs are about the same length. As in several related species, the pronotum and forewings are decorated with dark transverse bands. The bug feeds on plant debris and microscopic organisms. Courting males 'sing' loudly by rubbing their front legs against the head.

SIZE 6–8 mm.
HABITAT Weedy ponds and slow-moving water, but the bug can fly and is often seen far from water.
RANGE All Europe.
SEASON All year.
SIMILAR SPECIES There are many, ranging from about 5 mm to 15 mm in length.

This noisy insect sucks sap from pines and other trees with its stout beak. The male attracts the female with a monotonous whistling noise, made by vibrating tiny membranes on the sides of his body. Look for the eleven dark spots on the forewing. Freshly emerged adults are pale green. The nymphs spend several years sucking sap from roots in the soil.

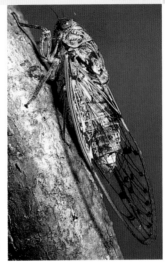

SIZE Up to 40 mm.
HABITAT Anywhere with trees, especially pines.
RANGE S Europe.
SEASON June–September.
SIMILAR SPECIES Several other cicadas live in Europe, but none has as many spots on the wings.

Buffalo Treehopper

102 *Stictocephalus bisonia*

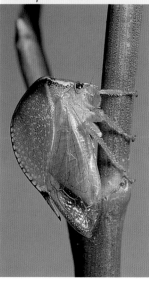

This agile little insect lives on a wide range of woody and herbaceous plants. It makes tremendous leaps when disturbed and can also fly well. Look for the sharp horns on each side of the thorax. Dead insects loose their bright green colour and fade to a dirty yellow. Eggs are laid in slits cut in twigs and the insects can cause serious damage to fruit trees.

SIZE Up to 10 mm.
HABITAT Anywhere with trees, shrubs or tall herbaceous plants.
RANGE An American insect, now well established in the western parts of S & C Europe.
SEASON July–September.
SIMILAR SPECIES None.

Common Froghopper

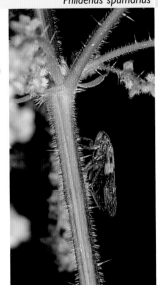

Also called a spittlebug, this jumping bug is one of several species causing 'cuckoo-spit' on plants in the spring: the frothy blobs have nothing to do with cuckoos. The young froghoppers produce the froth when they start to feed. It protects them from drying out as well as from some potential enemies. The adult pattern is very variable and the head is sometimes very pale.

SIZE 6 mm.
HABITAT Any well-vegetated area, feeding on a wide range of shrubs and herbaceous plants.
RANGE All Europe.
SEASON June–September, but 'cuckoo-spit' April–July.
SIMILAR SPECIES There are several, but most have a central ridge or keel on the pronotum.

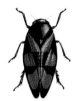

Despite its bright colours, which warn of an unpleasant taste, this bug is closely related to the Common Froghopper (p.103) and its relatives. It feeds on a wide range of shrubs and herbaceous plants and leaps away when disturbed. The nymphs live communally on roots, protected by a mass of solidified froth.

SIZE 8–12 mm.
HABITAT Most well-vegetated places, but most common in scrubby areas and on woodland margins.
RANGE S & C Europe.
SEASON April–August.
SIMILAR SPECIES *C. sanguinolenta* and *C. arcuata*, both absent from British Isles, have straighter rear red bands.

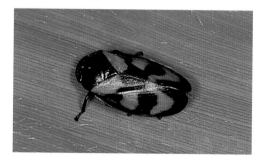

Dictyophara europaea

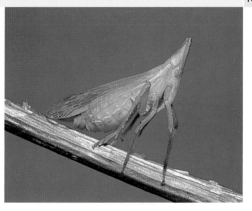

The conical head and the network of green veins on the transparent wings instantly identify this insect. It feeds on a wide range of herbaceous plants, especially members of the carrot family, and leaps vigorously away when disturbed. Older insects and dead specimens are usually much yellower than the insect shown here.

SIZE 10–14 mm.
HABITAT Most kinds of herbaceous vegetation.
RANGE S & C Europe, but not British Isles.
SEASON June–October.
SIMILAR SPECIES None.

Ledra aurita

Easily identified by the ear-like flaps on the thorax, this bug is rarely noticed because it is so well camouflaged on the lichen-covered branches where it normally lives and feeds. Even on a leaf, it can easily be mistaken for a bird dropping or a sliver of bark or lichen. It has no close relatives in Europe.

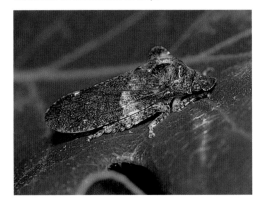

SIZE 10–15 mm.
HABITAT Deciduous woodland, especially oak woods.
RANGE Most of Europe, wherever there are woods.
SEASON May–October.
SIMILAR SPECIES None.

Green Leafhopper

The female, shown here, is largely green, often with a distinctly blue tinge, but the male forewings are usually purplish-brown or even black. Look for the yellowish head with conspicuous dark spots. The front half of the pronotum is often yellowish in both sexes and the rear half is dark green. The bug feeds mainly on grasses.

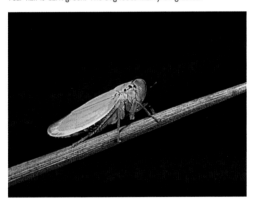

SIZE 6–8 mm.
HABITAT Damp grassland and marshes.
RANGE All Europe.
SEASON July–October.
SIMILAR SPECIES Although there are many other green leafhoppers, none of them has quite the same colour or pattern.

108 *Graphocephala fennahi*

The coloration of this little bug makes it quite unmistakable. It jumps and flies when disturbed, but rarely moves very far. Eggs are laid in the flower buds of rhododendrons in late summer and autumn and they hatch in the spring. A native of North America, the bug is now well established in southern Britain.

SIZE 8–10 mm.
HABITAT Woods, heaths and gardens – wherever there are rhododendron bushes.
RANGE Confined to southern Britain in Europe, but spreading.
SEASON June–October.
SIMILAR SPECIES None.

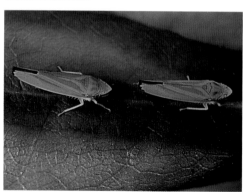

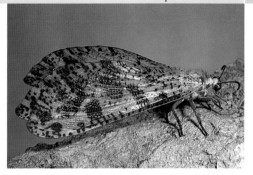

Look for the clubbed antennae to distinguish this day-flying insect from the dragonflies. It flies slowly and plucks small insects from the vegetation. At rest, it folds its wings back along its body. Males have long claspers at the rear. The larva lives in loose soil and debris and darts out to grab prey in its huge jaws.

SIZE 60 mm: wingspan 120 mm.
HABITAT Sand dunes and other rough grassland or bushy places with light soil.
RANGE S Europe.
SEASON May–September.
SIMILAR SPECIES None.

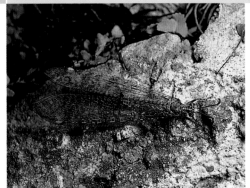

This insect usually rests in vegetation by day and is not easy to see. It sometimes comes to lighted windows at night. Its flight is slow and fluttery. The forewing has several dark spots, but the hindwing has just a few spots near the front. The larva lives in a small conical pit in bare ground. Ants and other insects that tumble in are grabbed by the large jaws.

SIZE 30 mm: wingspan 55–65 mm.
HABITAT Open woodland and scrub.
RANGE S & C Europe, including eastern England.
SEASON June–September.
SIMILAR SPECIES There are many, differing mainly in the detailed pattern of the wing veins. Not all the larvae make pits.

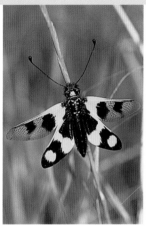

This fast-flying insect belongs to a group known as ascalaphids, easily recognised by their long clubbed antennae. They fly in sunshine and catch other insects on the wing. As soon as the sun goes in they settle on the vegetation and fold their wings roofwise over the body to give a triangular profile. The larvae feed on other insects in soil and leaf litter.

SIZE 35 mm: wingspan 45–50 mm.
HABITAT Rough grassland.
RANGE E & SE Europe.
SEASON May–August.
SIMILAR SPECIES Several species in S & C Europe are superficially similar, but lack the dark bars on the forewings.

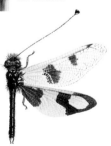

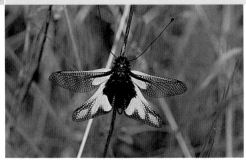

The pale areas on the wings range from pale cream to butter-yellow. Note that most of the veins are dark and the black at the base of the hindwing reaches almost or right to the rear corner. As in all ascalaphids, the males have claspers at the rear. This species behaves in exactly the same way as *L. macaronius* (p.111).

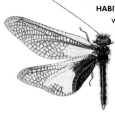

SIZE 20 mm: wingspan 45–60 mm.

HABITAT Rough, dry grassland and open woodland.

RANGE S & C Europe except British Isles.

SEASON April–August.

SIMILAR SPECIES *L. longicornis* has a smaller black patch at the base of the hindwing and most of the veins are yellow.

Look for this delicate insect drifting lazily over the ground in the sunshine. It alights on flowers and nibbles pollen, and may sip nectar as well. Males dance up and down in the evening, when their long, banded, ribbon-like hindwings probably act as signals to attract females. The long-necked larva is a ground-living predator.

SIZE 70 mm (including hindwings): wingspan 60 mm.
HABITAT Dry, stony hillsides with sparse vegetation.
RANGE SE Europe.
SEASON May–June.
SIMILAR SPECIES *N. bipennis* from Spain and *N. coa* from southern France are brown and yellow.

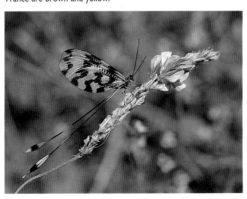

Mantis Fly

Mantispa styriaca

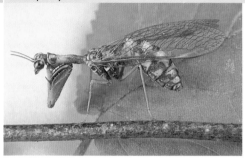

Flimsy wings with a dense network of veins distinguish this from a true mantis (p.76). It catches prey by shooting out its spiky front legs just like a mantis, but it is a more timid insect and preys only on small flies. It is active by day and night and flies well in warm weather. The larvae feed on the eggs in the egg sacs of spiders, especially wolf spiders.

SIZE 18 mm.
HABITAT Grassland, bushy places and light woodland on well-drained soils.
RANGE S Europe.
SEASON May–August.
SIMILAR SPECIES Four other species live in S Europe.

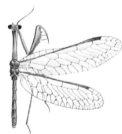

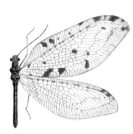

This lacewing is easily identified by its large size and spotted wings. Look also for the rust-coloured head. The insect flies mainly at night. The larvae live in moss and debris close to water and feed on a variety of other insects. Winter is passed in the larval stage.

SIZE 20–30 mm: wingspan 50 mm.
HABITAT Damp, shady woodlands, especially by streams.
RANGE S & C Europe, including southern British Isles.
SEASON April–August.
SIMILAR SPECIES None.

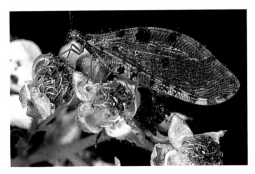

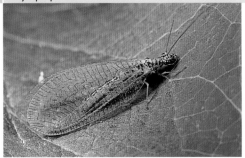

This common lacewing has a strong bluish tinge and its head and body are heavily marked with black. Many of the fine cross-veins are also black. Note the golden or brassy eyes that give this insect and its relatives the alternative name of golden-eye. Both adults and larvae are voracious predators of aphids – in common with its numerous relatives.

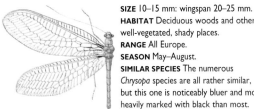

SIZE 10–15 mm: wingspan 20–25 mm.
HABITAT Deciduous woods and other well-vegetated, shady places.
RANGE All Europe.
SEASON May–August.
SIMILAR SPECIES The numerous *Chrysopa* species are all rather similar, but this one is noticeably bluer and more heavily marked with black than most.

This large, bright green lacewing has a small but conspicuous black spot between the bases of the antennae. Look also for the six other black dots on the head. In common with most green lacewings, it flies mainly by night.

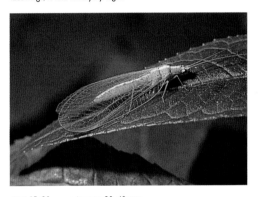

SIZE 15–20 mm: wingspan 30–40 mm.

HABITAT Well vegetated places, including woods, hedgerows and gardens.

RANGE S & C Europe except Scotland.

SEASON May–August.

SIMILAR SPECIES *C. ventralis* is black under the abdomen. The many other similar species are either bluish-green like *C. perla* (opposite) or lack the black spots on the head.

Brown Lacewing

Drepanepteryx phalaenoides

With its hooked wing-tips, this moth-like lacewing is easily identified, although it is often overlooked because of its strong resemblance to a dead leaf. Dark lines on the forewing are just like leaf veins. Note the numerous longitudinal veins – not present in the green lacewings – and the abundant forked veinlets at the front edge of the wings.

SIZE 15–20 mm: wingspan 25–35 mm.
HABITAT Deciduous trees, including orchard trees, but especially on oaks in light woodland.
RANGE Most of Europe, but more common in N & C: rare in southern British Isles.
SEASON May–October.
SIMILAR SPECIES None.

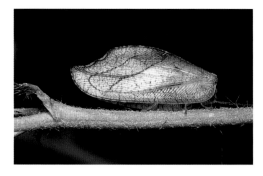

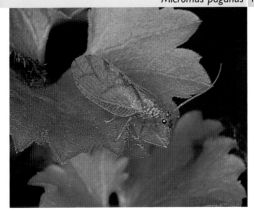

The rust-coloured streaks on the pale brown wings distinguish this species from most other lacewings. The forewings are also relatively broad, with pointed tips. The forked veinlets on the front edge of the wing are characteristic of most brown lacewings.

SIZE 7–10 mm: wingspan 15–20 mm.

HABITAT Deciduous woods and hedgerows, frequenting various trees and shrubs, especially elder.

RANGE Most of Europe.

SEASON May–September.

SIMILAR SPECIES Wings of *M. angulatus* are darker, spanning under 15 mm, and with rounder tips.

Alder Fly

Sialis lutaria

Easily recognised by its smoky wings, which have relatively few veins; these are dark and widely-spaced and do not fork at the tips. The adults, usually seen resting on waterside objects, rarely feed, but may nibble algae and pollen grains. They fly weakly when disturbed. The rather feathery, aquatic larva is highly predatory.

SIZE 15–20 mm: wingspan
20–30 mm.
HABITAT Edges of ponds and
slow-moving streams.
RANGE Most of Europe.
SEASON April–August.
SIMILAR SPECIES Several live in N
& C Europe, some spending their
larval life in faster-flowing water.

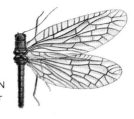

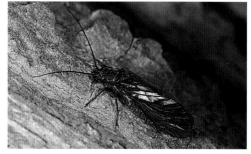

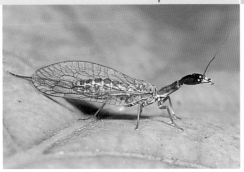

Snake flies are easily identified by the long 'neck'. The female, shown here, has a long, slender ovipositor, but otherwise the sexes are alike. Like most snake flies, this species has just one vein crossing the coloured patch (pterostigma) near the wing-tip. It is associated with conifers, where the larvae feed on other insects under loose bark.

SIZE 15–20 mm.
HABITAT Coniferous woodland.
RANGE S & C Europe, mainly in the W.
SEASON May–July.
SIMILAR SPECIES Three other species in British Isles and several more on the continent differ slightly in head shape and vein pattern. *R. notata*, associated with oaks, has two veins in the pterostigma.

Look for the rather narrow, spotted wings and the stout beak characteristic of the scorpion flies. Only the male, shown here, has the up-turned tail that gives these harmless insects their name. The tip of the female abdomen has the same chestnut colour as the male, but it is slender and tapering. The larvae live in the soil and, like the adults, they are scavengers.

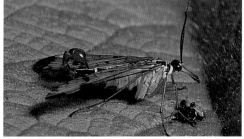

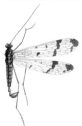

SIZE 15–20 mm: wingspan 30 mm.
HABITAT Nettle-beds, hedgerows and other lush vegetation.
RANGE Most of Europe.
SEASON April–August.
SIMILAR SPECIES About 30 species live in Europe, mostly in the S. The spots vary but the only sure way to distinguish them is to examine the genitalia.

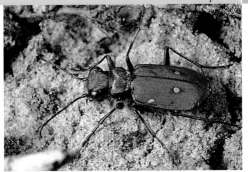

This sun-loving beetle is most likely to be seen scuttling rapidly over the ground in search of insects, but it flies with a buzzing sound when disturbed. The yellow spots vary in pattern and extent and the ground colour may be much darker than on the beetle shown here. Note the purple or coppery edges of the elytra. The larvae lurk in burrows and ambush passing prey.

SIZE 10–15 mm.
HABITAT Heaths and other sandy places, including coastal dunes.
RANGE Most of Europe.
SEASON April–September.
SIMILAR SPECIES *C. germanica* is smaller, with a bronze pronotum.

Cicindela sylvatica

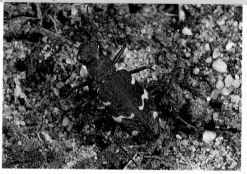

Look for the narrow cream streaks on the elytra, with two discrete round spots near the rear. The underside is metallic blue or violet. This fast-running predator is found mainly on the ground but, in common with other tiger beetles, it flies when disturbed. The larvae live in vertical pits or burrows and grab ants and other passing insects.

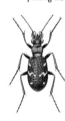

SIZE 15–20 mm.

HABITAT Heaths and open woods, especially pine woods, on sandy soils.

RANGE Most of Europe: rare in British Isles and far S.

SEASON April–August.

SIMILAR SPECIES *C. hybrida* is more rust-coloured, with wider pale streaks. The spots at the rear of the elytra are incorporated in an extra band.

This handsome insect lives mainly in trees. The parallel-sided elytra range from golden-green to bronze. Look for the bluish pronotum with raised borders all round. Both adult and larva feed on caterpillars, including those of the damaging gypsy moths and processionary moths. Because of this, the beetle is legally protected in some countries.

SIZE 15–30 mm.
HABITAT Woodlands and scrub of all kinds.
RANGE All Europe except far N, but not found in British Isles other than as a rare visitor.
SEASON All year, but dormant in the soil in winter.
SIMILAR SPECIES *C. inquisitor* is usually much darker – often almost black with a bronze tinge. The borders of the pronotum are raised only near the front.

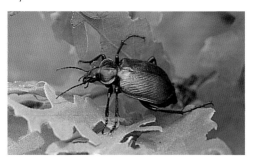

Carabus violaceus

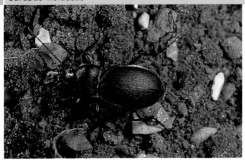

Look for the violet sheen around the pronotum and elytra to identify this common beetle. It hunts on the ground at night, feeding on worms, slugs and many other small creatures. It also eats carrion. By day, it is most often found under logs and stones. In common with many other ground beetles, it is flightless. The larvae are also predatory.

SIZE 20–35 mm.
HABITAT Almost anywhere, but most common in woods, hedgerows and gardens.
RANGE All Europe.
SEASON All year, but dormant in winter.
SIMILAR SPECIES Several ground beetles are superficially similar, but they either have ridged elytra or they lack the violet tinge.

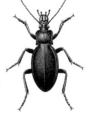

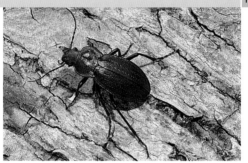

The elytra and pronotum of this flightless, nocturnal beetle range from bronze to brassy-green, often tinged with violet. Look for the fine ridges and three rows of small but conspicuous pits on the elytra. The female is less shiny and slightly less domed than the male, shown here. In common with the other ground beetles, both adult and larva are carnivorous.

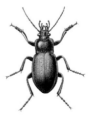

SIZE 20–30 mm.
HABITAT Almost anywhere, but especially common in woods, hedgerows and gardens.
RANGE All Europe except far N.
SEASON All year, but dormant in winter.
SIMILAR SPECIES Several others are similar, but their elytral spot patterns are different.

Look for the very oval outline of the elytra, each with three prominent ridges, to distinguish this species from most other green ground beetles. The margins of the elytra are raised and golden. The beetle is flightless and hunts on the ground at night. It is a major predator of slugs and cockchafer grubs.

SIZE 15–30 mm.

HABITAT Mostly open country, including farmland: also in gardens.

RANGE Most of Europe except far N: not native in British Isles, although temporary colonies sometimes occur after importation with crops.

SEASON All year, but most often seen in spring.

SIMILAR SPECIES *C. auronitens* has black elytral ridges. *C. monilis* has less obvious ridges.

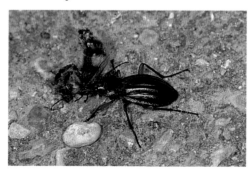

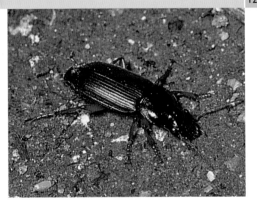

This very common, flightless ground beetle is easily identified by its black body and largely chestnut or rust-coloured legs and antennae. Look also for the more or less square pronotum with blunt rear corners. The beetle feeds mainly at night and, although basically carnivorous, it often damages strawberries and other fruit. It is sometimes called the strawberry beetle.

SIZE 12–20 mm.
HABITAT Farmland, gardens and other open areas.
RANGE All Europe.
SEASON All year, but dormant in winter.
SIMILAR SPECIES Many are superficially similar, but most have pointed corners at the rear of the pronotum.

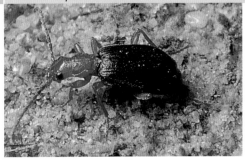

This ground beetle is named for its extraordinary defensive behaviour: when alarmed, it fires a hot, caustic fluid from its rear end like a puff of smoke. An audible pop accompanies the discharge. The elytra are black with blue or green iridescence. The antennae are orange with black bases. The beetle feeds on a variety of small invertebrates.

SIZE 5–10 mm.
HABITAT Dry grassland, especially on limestone, where it usually hides under stones.
RANGE Most of Europe except Scotland and far N.
SEASON All year, but dormant in winter.
SIMILAR SPECIES The few related species have entirely orange antennae.

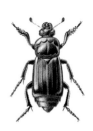

One of the burying or sexton beetles, so called because they bury the corpses of small animals. The beetles usually work in pairs to dig soil from below a corpse, and the female then lays her eggs on or near it. Adults and grubs eat the carrion, and also other insects scavenging on it. Note the very short elytra and the orange clubs on the antennae.

SIZE 18–30 mm.
HABITAT Almost anywhere, but most common in grassland and other open habitats.
RANGE Most of Europe except far N.
SEASON April–July.
SIMILAR SPECIES *N. germanicus* has black clubs on the antennae. The antennae of *Necrodes littoralis* are not clubbed.

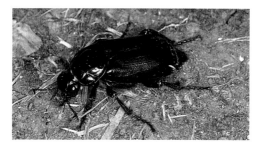

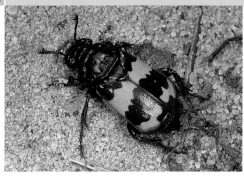

Differs from several similar burying beetles in having an uninterrupted front orange band and a narrow break in the rear band. Note also the straight hind tibia and orange-tipped antennae. The beetle's habits are similar to those of *N. humator* (p. 131).

SIZE 10–25 mm.
HABITAT Almost anywhere, but commonest in open areas.
RANGE Most of Europe except far N.
SEASON April–August.
SIMILAR SPECIES *N. interruptus* has both bands clearly broken. *N. vestigator* has two spots in place of the rear band. *N. vespilloides* has black antennal clubs. *N. vespillo* has curved hind tibiae.

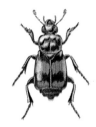

One of the largest of the rove beetles, characterised by the very short, almost square elytra that leave the bulk of the abdomen uncovered. It is also called the cock-tail because of the way in which it raises its rear end when threatened, as seen here. It hunts in leaf litter at night, catching slugs and other invertebrates in its enormous jaws.

SIZE 20–30 mm.
HABITAT Woods, hedgerows, gardens and many other places: often in sheds and outhouses.
RANGE Most of Europe.
SEASON All year, but dormant in the coldest months.
SIMILAR SPECIES *Creophilus maxillosus* is similar in size but has grey hairs on the elytra and abdomen.

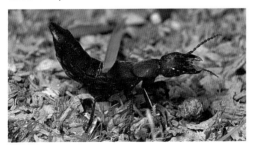

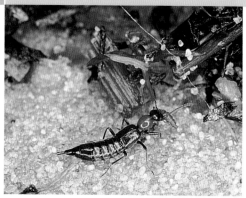

This rove beetle can be distinguished from several similar species by the globular orange or chestnut-coloured pronotum, blue-black elytra and completely black abdomen. In common with most rove beetles, it inhabits debris and eats a variety of living and dead animal matter. The beetle seen here is eating a fly pupa.

SIZE 5 mm.

HABITAT Damp places, especially the strand-lines on the edges of lakes and streams.

RANGE S & C Europe, but probably not in British Isles.

SEASON All year.

SIMILAR SPECIES Several other *Paederus* species have similar colours but all have pale abdominal patches.

This smooth and very shiny rove beetle is readily distinguished from similarly-coloured species by the broad head, clubbed antennae and pale 'shoulder-flashes' on the elytra. It has a slightly domed appearance when seen from the side. Adult and larva both feed on toadstools and other woodland fungi.

SIZE 7–12 mm.
HABITAT Woodlands of all kinds.
RANGE All Europe except far N.
SEASON All year, but most often seen in autumn.
SIMILAR SPECIES Many have similar colouring, but none has quite the same overall appearance.

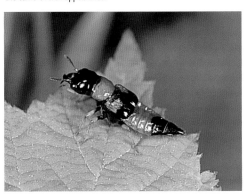

Stag Beetle

Lucanus cervus

The male's antlers are really overgrown jaws, used for wrestling contests if two males claim the same female. The female has normal jaws. The elytra range from chestnut to almost black. Look for the elbowed antennae and the three little teeth on the tibia of the middle leg. Adults feed on sap oozing from wounded trees. The fleshy white larvae live in decaying wood.

SIZE Female up to 35 mm: male to 50 mm.

HABITAT Woods, parks and hedgerows with old trees.

RANGE S & C Europe.

SEASON May–August, flying well in the evening.

SIMILAR SPECIES Lesser Stag Beetle (opposite) resembles female but has a more rectangular pronotum and only one tooth on the middle tibia: male lacks antlers.

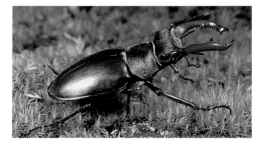

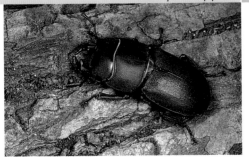

Despite its name, neither sex of this beetle has antlers. Note the very broad head and rectangular pronotum, which are more or less the same width. Look also for the single tooth on the middle tibia. This beetle flies strongly in the evenings. The larvae feed in old tree stumps and other rotting wood.

SIZE 20–30 mm.

HABITAT Mainly deciduous woodland and wooded parkland.

RANGE S & C Europe, including southern British Isles.

SEASON All year.

SIMILAR SPECIES Female Stag Beetle (opposite) has browner elytra, three teeth on middle tibia, and a head much narrower than the pronotum.

Geotrupes stercorarius

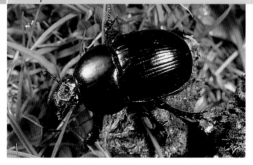

This very common dung beetle is dull black above and metallic blue or green below. Look for the smooth pronotum and the seven fine grooves running back from the front edge of each elytron: several other grooves run from the outer edge, beyond the 'shoulder'. The beetle flies well on warm evenings. It breeds mainly in dung dragged into burrows dug below cowpats.

SIZE 15–25 mm.
HABITAT In and around grazing pastures.
RANGE Most of Europe: mainly montane in the S.
SEASON April–October.
SIMILAR SPECIES Several are very similar but have a pitted pronotum or different grooving on the elytra. See also Bloody-nosed Beetle (p.176).

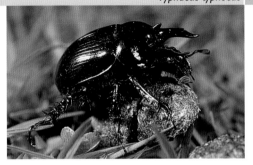

The male, shown here, is easily identified by the three forward-pointing horns on the pronotum – a small one in the middle and a long one on each side. The female has just two short points. Look for the shiny, strongly-ribbed elytra. The beetles bury dung, mainly that of sheep and rabbits, in deep burrows, and the larvae develop there.

SIZE 12–20 mm.
HABITAT Heathland and dry, sandy grassland.
RANGE Most of Europe except far N.
SEASON All year, but most often seen in spring and autumn: often seen flying in the evenings.
SIMILAR SPECIES None.

Scarab Beetle

Scarabaeus variolosus

The 'dimples' on the thorax and elytra identify this dung-rolling beetle. Note also the rake-like front legs. It rolls a ball of dung – usually from cattle, sheep or goats – until it finds a suitable spot in which to bury it. The buried dung forms a larder for the beetles and their grubs. Adult beetles fly with a loud buzzing sound and often fight over lumps of dung.

SIZE 15–25 mm.
HABITAT Grassy places with grazing mammals.
RANGE S Europe, especially in the E.
SEASON Throughout the year.
SIMILAR SPECIES *S. semipunctatus* has dimples only on the thorax.
S. laticollis has ridged elytra.

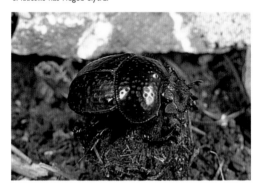

This dung beetle is easily identified by the slender horn on the head, although the female has a much shorter horn than the male, shown here. Look for the very shiny, ribbed elytra. The beetle flies well and is attracted to lights at night. It breeds mainly in cow-dung, which is buried in deep shafts dug under cowpats. The female lays her eggs in the dung.

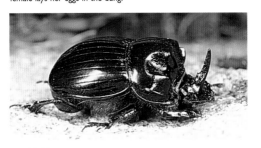

SIZE 15–20 mm.

HABITAT Grazing pastures and other grassland.

RANGE Most of Europe except far N, but very rare and confined to southern England in British Isles.

SEASON All year, but dormant in winter.

SIMILAR SPECIES *C. hispanus* of the Mediterranean region has a stouter and more curved horn.

Aphodius rufipes

Look for the reddish-brown legs that give this dung beetle its scientific name. Note also the smooth, shiny pronotum and head shield. The latter is smoothly rounded at the front and almost semi-circular. The beetle tunnels in cowpats and other dung and lays its eggs there. It does not bury the dung. It flies at night and often comes to lights.

SIZE 9–13 mm.
HABITAT Farms and grazing pastures, wherever there are large herbivores to provide the dung.
RANGE Most of Europe.
SEASON April–October.
SIMILAR SPECIES Several live in Europe, but are generally smaller.

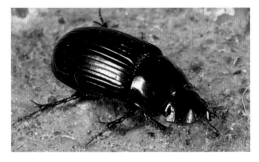

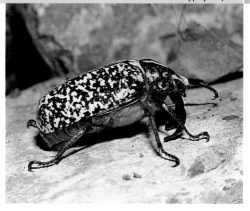

This hefty beetle flies after dark and is sometimes attracted to lights. The male, shown here, has huge curved, fan-like antennae, but the segments are folded together at rest. Females have smaller antennae. Adults chew pine needles and make loud screeching sounds by rubbing the abdomen against the underside of the elytra. The larvae feed on the roots of grasses and other plants.

SIZE 25–35 mm.
HABITAT In and around pine woods, mainly on sandy soil.
RANGE S & C Europe except British Isles.
SEASON June–August.
SIMILAR SPECIES None.

Cockchafer

Melolontha melolontha

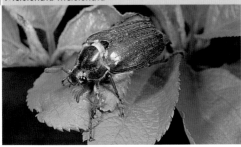

Also called the may-bug, this bulky beetle flies at night and often crashes into lighted windows. Look for the black pronotum and the pointed abdomen extending well beyond the elytra. The antennal club, larger in the male, shown here, than in the female, opens like a fan. Adults chew tree leaves: grubs eat roots and are serious cereal pests.

SIZE 20–30 mm.
HABITAT Woodland margins, hedgerows and gardens: egg-laying females in more open areas.
RANGE All Europe except far N.
SEASON May–July.
SIMILAR SPECIES *M. hippocastani* has a shorter 'tail'. Summer Chafer is smaller and hairier, with a brown pronotum and only three antennal flaps.

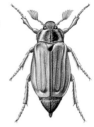

The head and pronotum often have a strong metallic green sheen. Note the sparse long hair on the pronotum. The antennae each have three flaps. The beetle flies by day and, despite its name, it is most common on rough grassland. The larvae feed on roots and do a great deal of damage to grazing pastures.

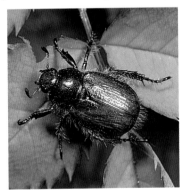

SIZE 7–12 mm.
HABITAT Grasslands of all kinds, including roadside verges: also in orchards.
RANGE Most of Europe except far N.
SEASON April–July.
SIMILAR SPECIES The head and pronotum of *Anomala dubia* are metallic green or blue and the pronotum lacks hair. *Omaloplia ruricola* has a black pronotum and black-edged elytra.

Hoplia caerulea

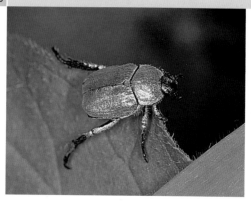

The male, shown here, is unmistakable in his coat of shiny blue scales. The female is greyish-brown. Look for the single large claw on each hind foot – a characteristic of all *Hoplia* species. The adults feed on the leaves of a wide range of plants, while the larvae are root-feeders.

SIZE 10–15 mm.
HABITAT Rough vegetation in damp places, especially river banks and damp woodlands.
RANGE S & C Europe except British Isles.
SEASON June–August.
SIMILAR SPECIES *H. argentea* is greenish-yellow in both sexes and could be mistaken for female *caerulea*.

Named for the stout, curved horn on the male's head. The female has no horn and a less ornate pronotum. The beetles fly at night and sometimes crash into lights. They breed in decaying wood, mainly oak, including piles of rotting bark and sawdust at sawmills. The larvae also flourish in rotting leaves.

SIZE 20–40 mm.
HABITAT Oak woods and the vicinity of sawmills.
RANGE S & C Europe except British Isles.
SEASON May–August.
SIMILAR SPECIES None.

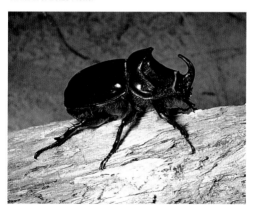

Bee Beetle

Trichius fasciatus

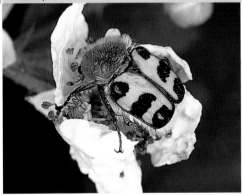

The elytral pattern varies but, together with the furry thorax, it gives this harmless beetle a passable resemblance to a bumble bee. It feeds on pollen and is most likely to be found with its head deeply buried among the stamens of flowers. Look for the tooth-like projection near the middle of the middle tibia. The larvae develop in decaying tree stumps.

SIZE 10–15 mm.
HABITAT Wooded areas.
RANGE All Europe, but rare in British Isles.
SEASON May–August.
SIMILAR SPECIES *T. zonatus* and *T. sexualis* have no tooth-like projection on the middle tibia.

The pronotum and elytra vary from metallic green to coppery-red, according to the angle of viewing. The white spots vary in size and are occasionally absent. The beetles feed on the pollen of roses and many other shrubs and huge numbers, buzzing loudly as they fly, gather on freshly-opened flowers. Later in the year they attack fruit. The larvae develop in dead wood.

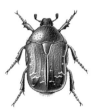

SIZE 14–21 mm.
HABITAT Woodland edges, hedgerows, scrub and gardens.
RANGE S & C Europe; mainly southern in British Isles.
SEASON May–August.
SIMILAR SPECIES *Cetonia cuprea* is almost identical, but has slight anatomical differences and prefers sap to pollen.

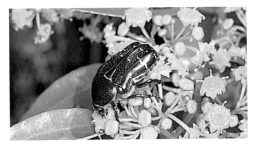

Athous haemorrhoidalis

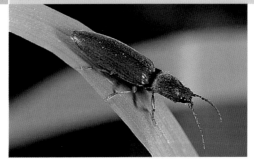

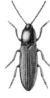

One of the commonest of the click beetles. Look for the strongly grooved elytra and light covering of grey or brown hair. Click beetles are named for their ability to jerk themselves into the air with a loud click if they are turned over. The soil-living larvae, called wireworms, are omnivorous, but some cause serious damage to crop roots.

SIZE 9–15 mm.
HABITAT Woodland margins, hedgerows, grassland and many other rough places.
RANGE Most of Europe.
SEASON May–August.
SIMILAR SPECIES *Agriotes lineatus* is smaller, with paler and more deeply grooved elytra. There are several other very similar species.

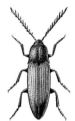

The elytra are either coppery or violet, as seen here, or brown with a coppery or violet patch at the rear. The pronotum is always violet or coppery. Note the sharply-pointed rear corners of the pronotum, characteristic of all click beetles. The female has less feathery antennae than the male, shown here. The larvae eat roots and various soil-dwelling invertebrates.

SIZE 12–15 mm.
HABITAT Rough grassland, especially in upland areas.
RANGE N & C Europe, including parts of upland British Isles.
SEASON May–July.
SIMILAR SPECIES None.

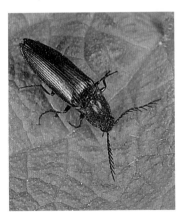

Soldier Beetle

152 *Cantharis rustica*

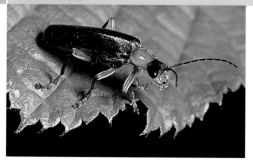

One of the commonest of the predatory soldier beetles, many of which have bright colours like old military uniforms. They also have soft elytra. Look for the brick-red leg-bases and pronotum. The latter normally has a central black spot, but it is absent in the beetle shown here. The face and the bases of the antennae are also brick-red.

SIZE 10–15 mm.

HABITAT Woodland margins, hedgerows and other rough places, often hunting on flowerheads.

RANGE Most of Europe.

SEASON May–August.

SIMILAR SPECIES The legs of *C. fusca* are completely black. The head of *C. livida* is all red.

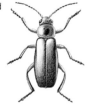

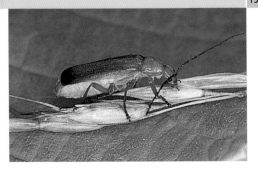

This very common soldier beetle is often called a bloodsucker because of its colour, but it is quite harmless. Look for the almost square pronotum and the black tips of the elytra to distinguish it from several similar species. It feeds on a variety of other small insects, which it often hunts on the flowers of hogweed and related plants.

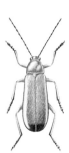

SIZE 10 mm.
HABITAT Hedgerows and other rough, flowery places.
RANGE Most of Europe.
SEASON May–September.
SIMILAR SPECIES *Cantharis livida* is larger, with a much rounder pronotum and no black tips to the elytra.

Glow-worm

Lampyris noctiluca

The insect's name comes from the wingless female, seen on the left of the photograph, although she is more like a woodlouse than a worm. She gives out a yellowish-green light as she sits in the grass at night. The male (see illustration below) has soft, dull brown wings and flies at night. On seeing a female's light, he drops down to mate as shown here. The larvae look like adult females and feed on small snails. Adults rarely feed.

SIZE 10–20 mm, females larger than males.
HABITAT Grassy and scrubby places, including roadside verges and hedgerows: mainly on lime.
RANGE Most of Europe: becoming rare in many areas.
SEASON June–August.
SIMILAR SPECIES *Phausis splendidula* is a little smaller and the female is much paler.

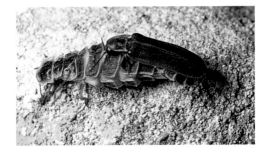

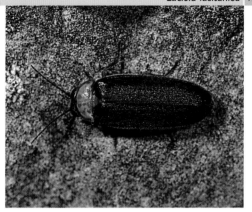

Look for the cream 'lamp' under the tip of the abdomen. Both sexes have wings, but only the male flies. He sends out a silvery-green flash about once every second after dusk, and a lot of fireflies flying together create a beautiful sight. The female sits in the grass and flashes a reply when she spots a male overhead. The larvae feed on snails, but the adults do not feed.

SIZE 10–12 mm.
HABITAT Grassland, scrub, vineyards and gardens.
RANGE S Europe, but only to the east of the River Rhône.
SEASON April–July.
SIMILAR SPECIES None.

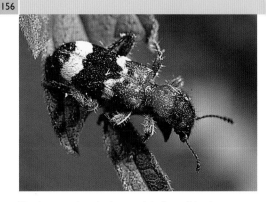

The chestnut-red on the thorax and the front of the elytra contrasts strongly with the black head and rear of the elytra. The two pale stripes on the elytra vary in size and shape. Look for the black legs. The beetle breeds under loose bark, mainly on conifer trees, where both adults and larvae feed on the grubs of other beetles, especially bark beetles.

SIZE 7–11 mm.

HABITAT Woodlands, especially coniferous woodlands.

RANGE All Europe.

SEASON March–July.

SIMILAR SPECIES *T. rufipes* has completely red legs. *Clerus mutillarius* of S & C Europe is larger and the thorax is completely black.

The thorax and the elytral bands vary from bright blue to almost black. Note that the front band on the elytra forms a shallow U. The tips of the elytra are red. The beetle is most often seen on flowers, where it nibbles pollen but feeds mainly on other flower-visiting insects. The larvae live parasitically in the nests of both social and solitary bees.

SIZE 8–15 mm.
HABITAT Almost any flowery habitat, including gardens.
RANGE S & C Europe except British Isles.
SEASON May–July.
SIMILAR SPECIES
T. apiarius has dark tips to its elytra and the front elytral band is almost straight.

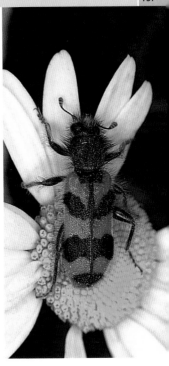

Cardinal Beetle

Pyrochroa coccinea

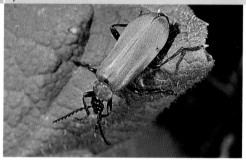

The elytra are rather flat and get wider towards the rear. Look also for the black head and toothed antennae. This beetle is most often seen on flowers and tree trunks, feeding on nectar, honeydew and oozing sap. The larvae are predatory and live under the bark of dead and dying trees.

SIZE 15–20 mm.
HABITAT Hedgerows and woodland margins and clearings.
RANGE N & C Europe except far N.
SEASON May–July.
SIMILAR SPECIES *P. serraticornis* has a red head. *Schizotus pectinicornis* has a black spot on the pronotum. *Dictyoptera aurora* has ridged elytra. Lily Beetle (p.175) has shiny wings and no toothed antennae.

Often mistaken for a ladybird (pp. 160–164), this beetle is much flatter and has much longer antennae. Look for the two large black spots on each elytron. The spot on the pronotum is not always very obvious. This beetle is a fungus-eater and is most often found under loose bark on dead and dying deciduous trees, especially beech.

SIZE 5 mm.
HABITAT Deciduous woodland and old hedgerows.
RANGE All Europe.
SEASON April–July.
SIMILAR SPECIES None.

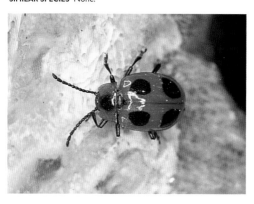

Seven-spot Ladybird

Coccinella 7-punctata

Seven black spots on the elytra identify this familiar garden insect. Note the strong-smelling fluid exuded if the insect is handled. This is its defence against birds and other predators. Adults and larvae are all voracious aphid-hunters. The steely-blue, yellow-spotted larvae of this and of the smaller two-spot ladybird are often abundant in gardens.

SIZE 5–9 mm.
HABITAT Almost anywhere: sometimes migrates in swarms.
RANGE All Europe.
SEASON All year, but dormant in winter, occasionally in large clusters.
SIMILAR SPECIES Scarce 7-spot Ladybird is rarely found far from wood ant nests. It may have extra spots.

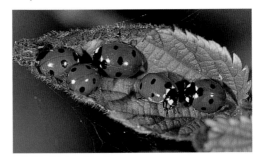

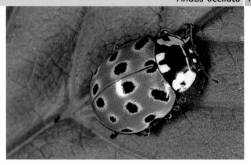

Each elytron normally has seven or eight black spots and these usually have pale rings around them, although the rings are sometimes missing. Look also for the two white spots on the rear edge of the pronotum. The largest of the British ladybirds, it lives mainly in pine trees and feeds on aphids. It hibernates in the adult stage.

SIZE 7–10 mm.
HABITAT Coniferous woods, especially pine woods.
RANGE Most of Europe.
SEASON All year, although it hibernates in winter.
SIMILAR SPECIES The pale rings, when present, and the two white spots at the rear of the pronotum separate this from all other ladybirds.

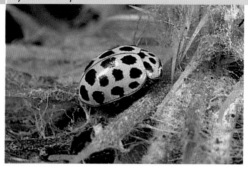

This little ladybird is easily identified by its bright yellow elytra and the 10 or 11 small, rounded black spots on each elytron. Unlike most other ladybirds, which feed on aphids and other small insects, this species feeds mainly on mildews.

SIZE 5 mm.

HABITAT Grassy places of all kinds, but not uncommon on gooseberries and other garden shrubs.

RANGE Most of Europe, but rare in the N.

SEASON All year, but dormant in the coldest months.

SIMILAR SPECIES Fourteen-spot Ladybird (opposite) has fewer spots and those on the pronotum are linked to form a 'crown'.

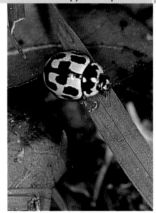

This very variable ladybird basically has seven rectangular black spots on each elytron, but they are often linked, as shown here, and are sometimes so extensive that the elytra look completely black. Alternatively, the spots may be so small that the beetle looks yellow. Look for the crown-like black patch on the pronotum. This species eats insects.

SIZE 5–7 mm.

HABITAT Almost anywhere with trees or shrubs.

RANGE Most of Europe except far N.

SEASON All year, but dormant in winter.

SIMILAR SPECIES Twenty-two Spot Ladybird (opposite) has 20 or 22 elytral spots, and distinct spots on the pronotum.

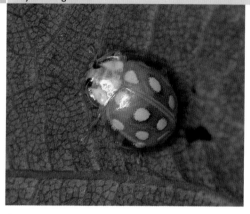

One of the few European ladybirds without any black. The ground colour is orange or yellow and there are six to eight pale spots on each elytron. There is little or no marking on the pronotum apart from a pale border on each side. This insect feeds on mildews.

SIZE 6–7 mm.

HABITAT Mainly woodland, particularly associated with sycamores.

RANGE Much of Europe, but local and never common.

SEASON All year, but dormant in leaf litter in winter.

SIMILAR SPECIES Cream-spot Ladybird and Eighteen-spot Ladybird both have a darker ground colour. Eighteen-spot has an ornate white border around the pronotum.

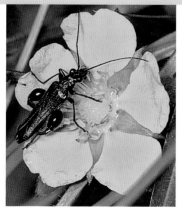

The male, shown here, is easily recognised by its swollen hind legs and gaping, bright green elytra that taper strongly towards the rear. Females are slimmer and lack the swollen hind legs. The beetle feeds on pollen and is most often seen in flowers. The larvae develop in the old stems of various plants, including sunflowers and ragwort.

SIZE 8–10 mm.
HABITAT Grassland, wasteland, hedgerows and gardens.
RANGE Most of Europe except Scotland and Ireland.
SEASON April–August.
SIMILAR SPECIES *O. virescens* is a duller green and rather hairy.

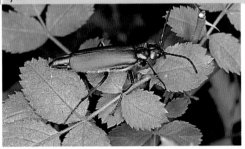

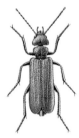

Despite its name, this is one of the blister beetles. It emits a skin-blistering liquid if handled. It varies from bright green to bluish-green and the body does not always extend beyond the elytra. The beetles eat the leaves of various trees, often in dense swarms. A strong mouse-like smell advertises their presence. The larvae are parasites in the nests of solitary bees.

SIZE 10–25 mm.
HABITAT Woodland margins and scrub.
RANGE S & C Europe, but rare in British Isles (southern England only).
SEASON May–August.
SIMILAR SPECIES Musk Beetle (p.169) has much longer antennae and more pointed elytra.

The commonest of several similar flightless beetles, named for the smelly, oily fluids they emit when alarmed. All have short, gaping elytra. The male (illustrated) is smaller than the female, shown below, and has conspicuously kinked antennae. Adults are plant-eaters, but the grubs live in the nests of solitary bees. They eat the bee eggs as well as the stored pollen and nectar.

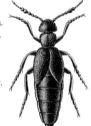

SIZE Male 10–25 mm: female 25–30 mm.
HABITAT Grassy places.
RANGE Most of Europe except far N.
SEASON April–July.
SIMILAR SPECIES *M. violaceus* is bluer and more finely punctured on head and thorax. *M. variegatus* has red and green abdominal bands.

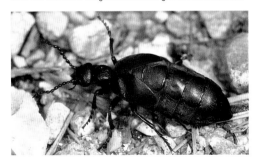

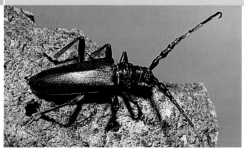

One of the longhorn beetles, named for their very long antennae.
The male antennae are much longer than those of the female,
shown here. Look for the wrinkled pronotum and the chestnut
tinge towards the tip of the elytra. The beetle flies rather slowly in
the evening. The larvae develop in various oaks and seriously
damage the timber.

SIZE 25–55 mm.

HABITAT Oak woods, including
Mediterranean cork oaks.

RANGE S & C Europe.

SEASON June–August.

SIMILAR SPECIES *C. velutinus* and *C. miles*
from the SE are similar. *Ergates faber* has
much shorter female antennae and a
smooth pronotum with two eye-like
marks in the male.

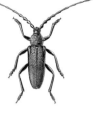

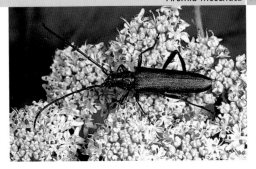

The colour ranges from bright, metallic green to bronze or coppery, occasionally with a strong blue sheen. The beetle emits a strong musk-like odour. It flies by day and sips nectar from flowers. The male antennae are longer than those of the female, shown here, and usually much longer than the body. This is true of most longhorn beetles. The grubs feed mainly in willows.

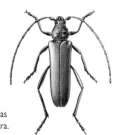

SIZE 15–35 mm.
HABITAT Almost anywhere with deciduous trees, but willows are the main food-plants.
RANGE Most of Europe.
SEASON June–August.
SIMILAR SPECIES Spanish Fly (p.166) has shorter antennae and less pointed elytra.

Look for the sharp spur on each side of the pronotum. The male, shown in the photograph, has black antennae about twice as long as the body. The female antennae have white or grey bands and are not much longer than the body. This longhorn beetle breeds in dead and dying conifers and its larvae cause damage to structural timbers.

SIZE 20–35 mm.
HABITAT Coniferous woods and plantations, mainly in upland areas.
RANGE C Europe: occasionally seen in British Isles, but probably only when imported with timber.
SEASON June–August.
SIMILAR SPECIES *M. galloprovincialis* has reddish-brown antennae and clearly banded elytra.

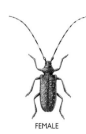

FEMALE

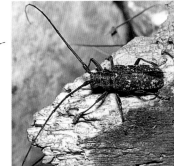

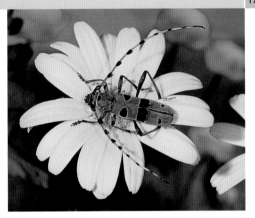

This rare and beautiful longhorn has a very variable black pattern on its powder-blue elytra, but cannot be confused with any other species. The larvae live in dying beech trunks. Better standards of forestry have led to the decline of the species in recent decades. Collecting has helped to make the beetle even rarer and it is now protected by law in several countries.

SIZE 15–38 mm.
HABITAT Mountain beech woods.
RANGE C & SE Europe except British Isles.
SEASON June–September.
SIMILAR SPECIES None.

Clytus arietis

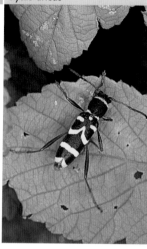

Named for its resemblance to various solitary wasps (see p.224), this longhorn beetle is quite harmless. The yellow banding on the elytra is variable. Look for the very rounded pronotum. The beetle can be seen feeding at flowers or scampering over logs and tree trunks and tapping the surface with its antennae. The larvae live in dead deciduous timber.

SIZE 7–15 mm.
HABITAT Woodlands, hedgerows and gardens.
RANGE Most of Europe.
SEASON May–July.
SIMILAR SPECIES *Plagionotus arcuatus*, probably extinct in British Isles although widespread elsewhere in Europe, has yellow spots on the thorax. See also *Strangalia maculata* (opposite).

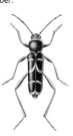

The elytral pattern varies and the spots near the front are often very faint or even absent, but tips are always black. Note the largely yellow legs, yellow bands on the antennae and tapered elytra. The insect shown here is about to fly, but the hindwings are normally concealed. Adults feed on pollen and the larvae develop in decaying tree stumps.

SIZE 14–20 mm.
HABITAT Hedgerows, woodland margins and clearings.
RANGE All Europe except far N.
SEASON June–August.
SIMILAR SPECIES *S. quadrifasciata* has clear black and yellow bands. *S. aurulenta* has golden antennae. Wasp Beetle (opposite) has a rounded pronotum.

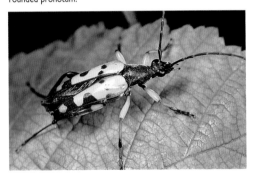

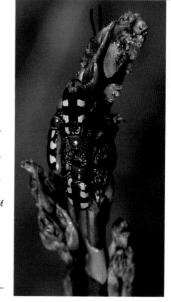

The three more or less square cream patches on each elytron are often larger than shown here, leaving three black cross-bands and a relatively narrow stripe down the middle. Look for the rust-coloured pronotum and edges of the elytra. The adults and the black-spotted grey larvae all chew the leaves of asparagus and the species is a serious pest in some areas.

SIZE 5–8 mm.
HABITAT Rough ground and gardens – wherever wild or cultivated asparagus grows.
RANGE S & C Europe, including southern British Isles.
SEASON All year, but dormant in soil in winter.
SIMILAR SPECIES None.

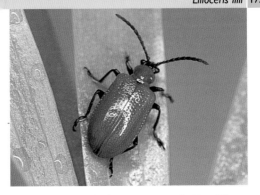

This brilliant leaf-eating beetle is a serious pest of cultivated lilies and also feeds on wild members of the lily family. Look for the orange grubs, clothed with black slime, feeding on the plants in the summer. There are up to three generations in a year. Adults of the final generation hibernate in the soil.

SIZE 6–8 mm.

HABITAT Gardens and anywhere else where plants of the lily family grow.

RANGE Most of Europe except far N. Rare in British Isles until recently, but spreading rapidly.

SEASON All year, but most often seen April–August.

SIMILAR SPECIES Cardinal Beetle (p.158) is flatter and less shiny and has comb-like antennae.

Timarcha tenebricosa

Named for its habit of exuding red 'blood' from its mouth when alarmed, this flightless beetle often has a strong bluish or purplish tinge. The domed elytra are fused together and the pronotum narrows strongly towards the rear. Look also for the very large feet. The adults and the shiny black grubs all feed on bedstraws and other low-growing plants.

SIZE 10–20 mm.
HABITAT Rough, grassy places: most often seen lumbering slowly across paths.
RANGE S & C Europe.
SEASON April–August.
SIMILAR SPECIES *T. goettingensis* is smaller and the pronotum is almost parallel-sided. Dor Beetle (p.138) has grooved elytra and clubbed antennae.

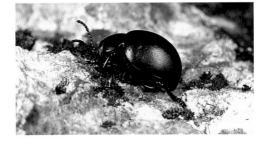

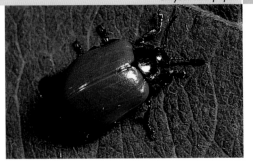

The elytra range from orange to dark red and are markedly wider than the pronotum at the shoulder. Each has a tiny black spot right at the tip. There may be other small black spots as well. The pronotum is usually dark green or bronze, but occasionally bluish or black. Adults and larvae feed on sallows and poplars.

SIZE 9–12 mm.

HABITAT Almost anywhere with sallows or poplars, including the dwarf willows of the N.

RANGE All Europe.

SEASON April–September.

SIMILAR SPECIES *C. tremula*, found on aspen, is smaller and has no black spots at the tip. *Chrysolina polita* has pronotum and elytra about the same width.

178 *Chrysolina menthastri*

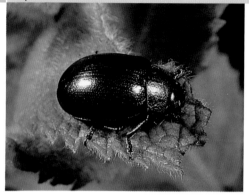

One of several brilliant metallic green leaf beetles. Look for the smoothly rounded, almost pear-shaped outline. This, together with its association with mints and related plants, distinguishes it from most other similar species.

SIZE 10 mm.
HABITAT On mints and related plants, mainly in damp places, including roadside ditches.
RANGE S & C Europe, including southern British Isles.
SEASON May–September.
SIMILAR SPECIES *C. fastuosa* is smaller. *Chrysomela aenea* lives on sallows. *Cryptocephalus* species are rather square at the rear and their heads are concealed under the pronotum.

This easily recognised beetle is a serious pest of potatoes. It came originally from North America. The adults and the fleshy pink or orange grubs feed on the leaves and reduce the plants to blackened stumps. Winter is spent as an adult hibernating in the soil. The beetle also feeds on nightshades and other members of the potato family.

SIZE 10 mm.
HABITAT Farms and gardens.
RANGE Widely distributed in Europe but not established in British Isles, where it should be reported to the police if found.
SEASON All year, although dormant in winter.
SIMILAR SPECIES None.

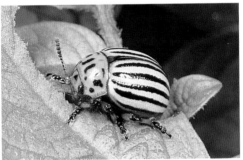

Cassida viridis

This beetle is extremely hard to spot at rest on a leaf because the pronotum and elytra extend beyond the body and are pulled tightly down on to the leaf to conceal all trace of shadow. Look for the rounded rear corners of the pronotum. Adults and larvae all feed on mints and related plants.

SIZE 7–10 mm.

HABITAT Rough vegetation with mints and related plants, especially near water.

RANGE Most of Europe except far N.

SEASON May–October.

SIMILAR SPECIES There are several slightly smaller species, often with red-streaked elytra. *C. rubiginosa* has more pointed rear corners on the pronotum.

This weevil varies from orange to deep red, with a rectangular black head and black legs. Look for the semicircular pronotum. The insect is named for the female's habit of rolling an oak leaf into a tight ball after laying an egg on it. The resulting grub feeds inside the ball. Sweet chestnut leaves may also be used.

SIZE 4–6 mm.
HABITAT In and around oak woods.
RANGE All Europe except far N and Ireland.
SEASON May–July.
SIMILAR SPECIES *Apoderus coryli*, which lives on hazel, has a more triangular pronotum and a bell-shaped black head. The legs are largely red.

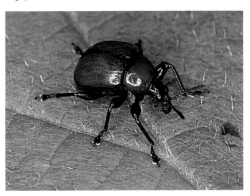

One of several common weevils that are clothed with shiny blue or golden green scales. The latter fall off with age and the elytra then appear largely black. The legs are also black, although usually clothed with greenish scales, and there is a strong tooth on each front femur. The insect is abundant on stinging nettles. Its larvae feed on the nettle roots.

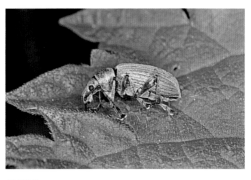

SIZE 7–9 mm.
HABITAT Hedgerows, waste ground and wherever else there are stinging nettles.
RANGE Most of Europe.
SEASON April–August, but mainly May–June.
SIMILAR SPECIES There are many superficially similar species, but most are found on trees and shrubs.

Look for the conspicuously striped elytra and pronotum, and the prominent eyes at the base of the broad, blunt snout. The insect is often abundant on peas, broad beans, clovers and other legumes, where it nibbles the leaf margins and leaves them with scalloped edges just like a postage stamp. The grubs feed on the roots of the plants and may cause serious damage to crops.

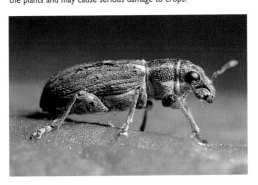

SIZE 5 mm.
HABITAT Grassland and cultivated and waste ground. Sometimes invades buildings in autumn.
RANGE All Europe.
SEASON All year, but dormant in debris in winter.
SIMILAR SPECIES Several attack other plants, but they are not easy to distinguish.

The female, shown here, has a snout about as long as her body. It is straight for about two thirds of its length. She bores into young acorns and chestnuts with it and lays her eggs there. The grubs feed inside the developing nuts. The male has a slightly shorter snout, with the antennae attached nearer to the tip. The pale scales often fall off and leave dark patches.

SIZE 6–10 mm, including the snout.
HABITAT Oak and chestnut woods.
RANGE S & C Europe except British Isles.
SEASON June–September.
SIMILAR SPECIES *C. nucum*, which attacks hazel nuts, has a shorter snout, curved for about half its length.

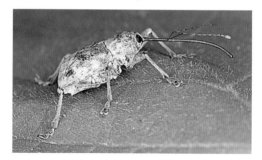

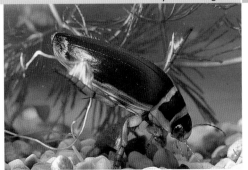

This large predator is the commonest of several similar species. Look for the yellow borders of the elytra and pronotum: both front and rear edges of the pronotum are yellow. The female is less shiny than the male, shown here, and usually has strongly furrowed elytra. Adults and larvae attack fish, frogs and many other aquatic creatures.

SIZE 25–35 mm.
HABITAT Weedy ponds and other still waters.
RANGE All Europe, uncommon in far S.
SEASON All year.
SIMILAR SPECIES *D. latissimus* is more angular, with bulging elytra. Most others lack yellow at the front and rear of the pronotum or have a yellow scutellum.

Ctenophora ornata

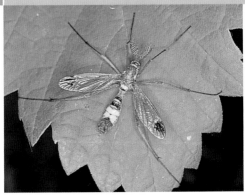

This attractive insect is one of the crane-flies, also called daddy-longlegs. The male, shown here, is easily recognised by the feather-like antennae. The female has much simpler antennae and, like other female crane-flies, she has a pointed abdomen for poking her eggs into crevices. The insects fly mainly at night. They breed in decaying timber.

SIZE 15–20 mm.
HABITAT Wooded areas with mature deciduous trees.
RANGE Most of Europe but rare in British Isles.
SEASON May–August.
SIMILAR SPECIES *C. atrata* is more slender, with less bushy antennae.

One of Europe's biggest flies in terms of length and wingspan, this crane-fly is easily identified by its wing pattern. Like most other large crane-flies, it rests with its wings wide apart, never laying them flat over its body. The female has a pointed abdomen, not the blunt tip of the male shown here. The larvae live in mud, especially at the edges of ponds and streams.

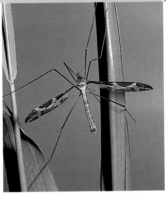

SIZE 30 mm: wingspan 65 mm.
HABITAT Marshes, riversides and damp woodland.
RANGE Most of Europe.
SEASON April–August.
SIMILAR SPECIES *T. vittata* is a bit smaller, with less extensive brown markings.

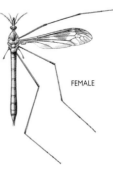

FEMALE

Spotted Crane-fly

Nephrotoma appendiculata

Easily identified by its clear, shiny wings and spotted body,
although the spots vary in size. It normally rests with its wings
folded flat over its body. The female, shown here, pushes the
tough, reddish tip of her abdomen into the soil to lay her eggs.
The grubs, known as leatherjackets, damage the roots of many
farm and garden crops.

SIZE 15–25 mm: wingspan 40–50 mm.
HABITAT Light woodland, roadsides, gardens and open country of
all kinds, especially farmland.
RANGE Most of Europe.
SEASON May–August.
SIMILAR SPECIES *N. quadrifaria* has a dark smudge and a streak
near the middle of each wing. *N. crocata* has a black abdomen with
yellow rings.

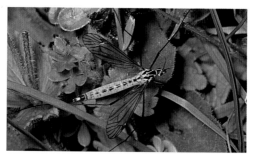

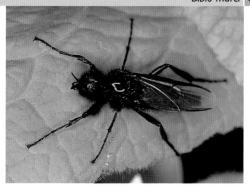

Huge swarms of these flies drift over shrubs and other vegetation in spring, often around St Mark's Day (25 April). With their legs dangling in sinister fashion, the flies may cause alarm, but they are quite harmless. Look for the stout spine halfway along each front leg. The female has much smaller eyes than the male, shown here. The fly breeds in soil and rotting vegetation.

SIZE 10–15 mm.
HABITAT Rough grassland, hedgerows, woodland margins and scrub.
RANGE Most of Europe.
SEASON April–May.
SIMILAR SPECIES *B. hortulanus*, common in gardens, has a similar male, but female is brick-red.

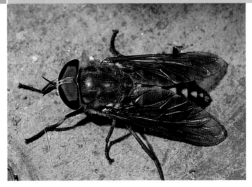

Look for the broad V formed by the veins at the wing-tip – a characteristic of all horse-flies. The colour varies, but the pale triangle on the rear half of each abdominal segment should distinguish this from most other horse-flies. Females suck blood from horses, cattle and other large mammals, including people, but males drink nectar. The larvae live in damp soil.

SIZE 20–25 mm.
HABITAT Damp pastures, especially near woods.
RANGE Most of Europe: mainly upland in British Isles.
SEASON June–August.
SIMILAR SPECIES *T. bovinus* usually has a browner abdomen and the triangles usually reach well into the front half of each abdominal segment.

One of several very similar species, all with patterned wings and beautiful iridescent green and purple eyes. They fly quietly and the females bite fiercely! Look for the V-shaped black patch on the second abdominal segment. The larvae develop in waterlogged soil and mud.

SIZE 10 mm.
HABITAT Damp woods and heaths, bogs and moors.
RANGE Most of Europe.
SEASON May–September.
SIMILAR SPECIES Other *Chrysops* species are very similar but have different abdominal patterns.

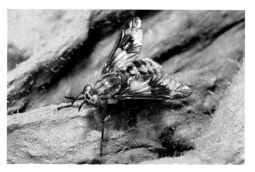

Cleg-fly

Haematopota pluvialis

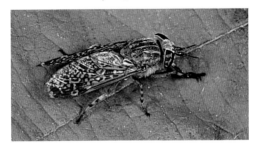

This common horse-fly flies silently and you do not notice it until it has sunk its spear-like mouth-parts into you and started to drink. The irritation from the bite can last for several days. It is most active in humid, overcast weather. Look for the mottled wings and brilliantly patterned eyes, typical of all *Haematopota* species. The larvae live in damp soil.

SIZE 10–12 mm.
HABITAT Almost all rural situations, but most common in damp areas, especially in light woodland.
RANGE All Europe.
SEASON May–October.
SIMILAR SPECIES *H. crassicornis* has a pale Y- or V-shaped mark in the cell in the middle of the wing. There are several others.

Bee-fly

Bombylius major | 193

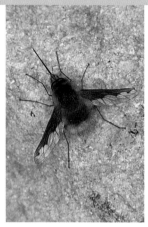

Although often mistaken for a bee, this harmless, furry fly is easily recognised by the long beak (or proboscis) and bold brown wing pattern. It darts rapidly from flower to flower and hovers well, but clings to flowers with its slender legs when feeding. Females drop their eggs in flight and the grubs develop as parasites in the nests of solitary bees and wasps.

SIZE 10–12 mm (excluding proboscis): wingspan 20–25 mm.
HABITAT Sunny spots in woodland rides and clearings, roadsides, fields and gardens.
RANGE All Europe.
SEASON March–June.
SIMILAR SPECIES There are several, mostly smaller and with less obvious wing patterns.

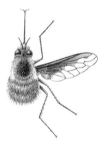

Look for the little clear 'windows' in the dark area of the wing membrane to identify this fly. It is closely related to the Bee-fly (p.193) and has the same darting and hovering flight, although it is less hairy and has only a very short beak. The larvae are parasites of caterpillars.

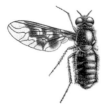

SIZE 8–10 mm: wingspan 12–15 mm.
HABITAT Heaths and other sandy areas.
RANGE N & C Europe.
SEASON June–August.
SIMILAR SPECIES *Anthrax anthrax* has no 'windows' in the dark area of the wing membrane.

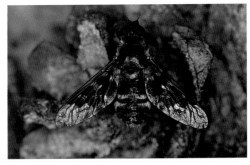

Like most robber-flies, this robust, fast-flying insect catches other insects in midair. It darts out from a perch when a suitable victim appears. Look for the stout beak, which penetrates the victims, the sturdy legs and the hairy face. The bristles protect the robber-fly's eyes from its struggling victims. It breeds in cowpats and other dung.

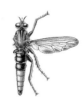

SIZE 20–30 mm.
HABITAT Open country of all kinds, as long as there are mammals to provide the dung.
RANGE Most of Europe.
SEASON June–October.
SIMILAR SPECIES None.

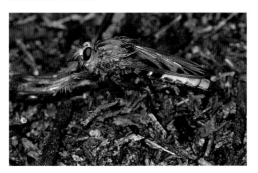

Chrysotoxum cautum

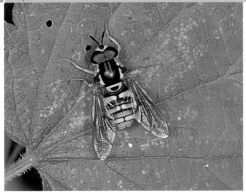

Look for the long, forward-pointing antennae and the yellow-ringed scutellum to distinguish this species. The wasp-like colours protect it from predators. As in all hover-flies, the veins at the rear of the wing form a false margin parallel to the edge. This species breeds in ants' nests, where the larvae eat aphids.

SIZE 10 mm.

HABITAT Hedgerows and woodland rides and margins, usually basking on the leaves.

RANGE S & C Europe, including southern British Isles.

SEASON May–August.

SIMILAR SPECIES Other *Chrysotoxum* species differ slightly in hairiness and abdominal pattern.

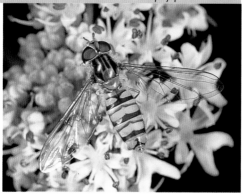

Look for the pattern of broad and narrow black bands on the abdomen to identify this very common hover-fly. It is a great migrant and British populations are often augmented by huge invasions from the continent. The flies swarm over plants, collecting pollen and nectar and also feeding on honeydew. They often enter houses. The larvae eat aphids.

SIZE 10 mm.
HABITAT Anywhere with flowers: especially fond of umbellifers and often abundant in gardens.
RANGE All Europe.
SEASON All year, but usually dormant in winter.
SIMILAR SPECIES None.

Hover-fly

Scaeva pyrastri

The white or cream marks on the abdomen are narrower in the middle than at the ends, and the inner arm of each mark extends further forward than the outer arm. Populations fluctuate a great deal and are often augmented by immigration. The larvae eat aphids.

SIZE 12–15 mm.

HABITAT Flowery places of all kinds, including gardens and waste land.

RANGE Most of Europe, but rare in Scotland and far N.

SEASON May–November.

SIMILAR SPECIES *S. selenitica* has comma-shaped abdominal marks with the outer arm strongly tapered and reaching just as far forward as the inner arm.

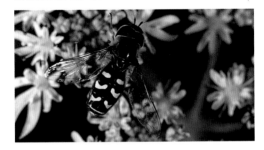

The broad, pale band near the front of the abdomen distinguishes this from most other hover-flies. The first two long veins meet just before reaching the wing-tip. Look also for the black scutellum and the brown-tinged veins. The larvae live as scavengers in wasps' nests.

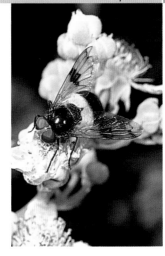

SIZE 10–15 mm.

HABITAT Woodland clearings and margins, often feeding at bramble blossom.

RANGE Most of Europe except far N.

SEASON May–September.

SIMILAR SPECIES *Leucozona lucorum* is superficially similar, but has a brown scutellum and the first two long veins both reach the wing margin.

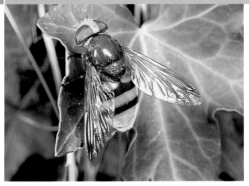

This large hover-fly bears an uncanny resemblance to a Hornet (p.236), especially in flight. It even sounds like a Hornet. Look for the chestnut patches at the front of the abdomen. The female is shown here. The male, in common with most flies, has larger eyes that meet in the middle of the head. The larvae live as scavengers in wasps' nests.

SIZE 15–25 mm.
HABITAT A wide range, including urban areas, but most common in and around woodland.
RANGE S & C Europe, including southern England.
SEASON May–October.
SIMILAR SPECIES *V. inanis* is smaller, with yellow at the front of the abdomen. See also Hornet.

Named for its resemblance to a male Honey
Bee (p.244), this hover-fly is often seen basking
on walls or hovering in shafts of sunshine.
Look for brush-like hairs on the hind leg and a
wide, dark stripe running down the face. The
pale abdominal marks vary and are sometimes
absent. The larva, called a rat-tailed maggot,
lives in stagnant water.

SIZE 10–15 mm.
HABITAT Flowery areas of all kinds, including gardens.
RANGE All Europe.
SEASON All year: hibernates in winter, but often wakes and basks
on walls on sunny days.
SIMILAR SPECIES Several other *Eristalis* species are similar but have
no more than a narrow facial stripe and have no brush-like hairs
on the hind leg.

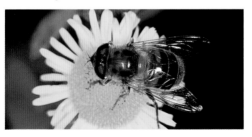

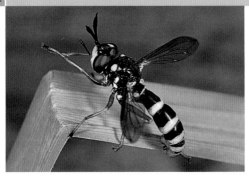

The narrow 'waist' and long antennae combine with the coloration to give this fly a strong similarity to a solitary wasp (p.224), although it has only two wings. Look also for the long beak (or proboscis). The fly frequents a wide range of flowers, including scabious and ragwort, where it mingles with bumble bees and lays eggs on them. The grubs develop inside the bees.

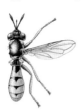

SIZE 8–12 mm.
HABITAT Flowery places, mainly on well-drained soils.
RANGE Most of Europe.
SEASON June–September.
SIMILAR SPECIES There are several related species, differing slightly in their abdominal patterns.

This slender fly is named for its long, thin legs. Look also for the flat head which is strongly pointed at the front. It is most often seen crawling slowly over vegetation in damp places. It breeds in decaying matter, including garden compost heaps.

SIZE 10 mm.
HABITAT Woods, river banks, roadsides and other damp, shady places with abundant vegetation.
RANGE Most of Europe.
SEASON May–September.
SIMILAR SPECIES *M. lateralis* of S & C Europe has more yellow on the abdomen. *M. brevipennis* of C Europe (not British Isles) is all black with shorter wings.

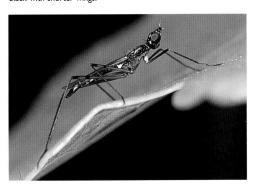

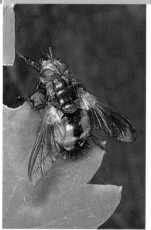

This rather bristly fly is distinguished from most of its relatives by the broad black abdominal stripe and the yellow hair on the face. Look also for the yellowish tinge at the base of the wing. The fly is most often seen on flowers or basking on leaves. It is a parasitic species. It lays its eggs on leaves and the resulting grubs bore into various caterpillars.

SIZE 10–15 mm.

HABITAT Rough vegetation with plenty of flowers, especially in damp areas.

RANGE All Europe.

SEASON April–September.

SIMILAR SPECIES *Gonia divisa* lacks yellow wing bases. *Dexia rustica* is more slender and also lacks yellow wing bases.

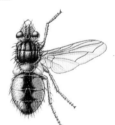

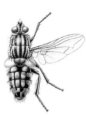

One of several very similar flies with red eyes and very large feet. Note also the chequered black and grey abdomen, whose pattern varies with the angle of view. Although adults often feed at flowers, they are strongly attracted to carrion and dung, where the females give birth to larvae instead of laying eggs. The larvae feed in the rotting material.

SIZE 12–20 mm.
HABITAT Almost anywhere: common around houses, although rarely found indoors.
RANGE All Europe.
SEASON All year: often basks on walls in winter sun.
SIMILAR SPECIES Other *Sarcophaga* species are very difficult to distinguish. Many smaller flies have similar abdominal patterns.

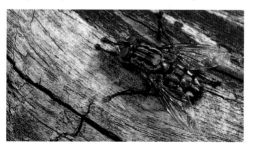

Bluebottle

Calliphora vomitoria

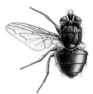

This is the common blow-fly that makes so much noise as it buzzes around our houses in search of a way out. Females are strongly attracted to meat or fish of any kind, where they lay their eggs. Males are more likely to be found on flowers. Note the sharp kink in the outer part of the fourth long vein, characteristic of all the blow-flies.

SIZE 10–12 mm.
HABITAT Many habitats, but especially common in and around human habitation.
RANGE All Europe: probably worldwide.
SEASON All year, often basking on walls in winter sunshine.
SIMILAR SPECIES There are several very similar flies, very difficult to distinguish without a lens.

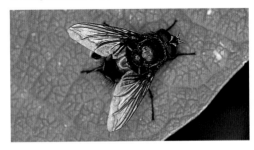

Cluster-fly

Look for the chequered abdomen and the golden or silvery hairs on the thorax. Note how the abdominal pattern alters with different viewpoints. The fly is named for its habit of hibernating in dense clusters in attics and out-houses. The larvae develop as parasites inside earthworms.

SIZE 8–10 mm.
HABITAT Almost anywhere apart from heathland and montane areas.
RANGE All Europe.
SEASON All year, but most often seen basking on walls and tree trunks in autumn and spring.
SIMILAR SPECIES None.

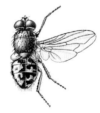

Greenbottle

208 *Lucilia caesar*

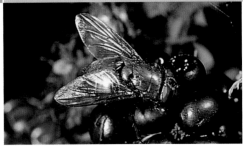

One of several metallic green flies. Look for the sharply-bent fourth long vein and the silvery jowls below the eyes. The fly can be found on flowers and carrion, and basking on sunny walls. The larvae are carrion-eaters. Eggs are sometimes laid in wounds on sheep and the maggots tunnel into the flesh. Such infestations are called sheep-strike.

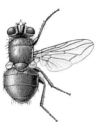

SIZE 8–15 mm.
HABITAT Almost anywhere: often around houses, but rarely going inside.
RANGE All Europe.
SEASON All year, often basking in winter sunshine.
SIMILAR SPECIES *Cynomyia mortuorum* has yellow jowls. *Orthellia cornicina* has green jowls. Other *Lucilia* species are very difficult to distinguish.

Easily recognised by its shiny black body and the bright yellow or orange patch at the base of each wing. This fly is very fond of umbellifer flowers and bramble blossom, but is just as likely to be seen basking in full sun on the ground or on walls and tree-trunks. It breeds in the dung of cattle and other large mammals.

SIZE 10 mm.
HABITAT Woods, hedgerows and pastureland.
RANGE All Europe.
SEASON March–October.
SIMILAR SPECIES *M. mystacea*, not found in British Isles, is larger, with brown hair on the thorax.

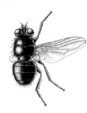

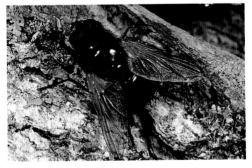

Common House-fly

Musca domestica

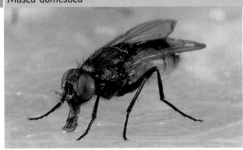

Look for the grey-and-black striped thorax, the yellow or orange abdominal patches, and the sharply-bent fourth long vein. It is less common in houses than in the past because of better sanitation and fewer horses to provide the dung for breeding. It does not bite but its liking for excrement means that it carries numerous disease-causing germs.

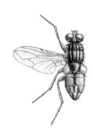

SIZE 5–8 mm.
HABITAT Human habitation, especially around farms and rubbish dumps with abundant decaying matter.
RANGE Worldwide.
SEASON All year, but most noticeable in summer.
SIMILAR SPECIES Face-fly, abundant on farm animals, is almost identical. The fourth long vein of Lesser House-fly, very common in houses, is almost straight.

This fly abounds on fresh cow-dung in summer. Scores of golden-haired males may settle on a single cowpat. The female, seen here below the male, is less hairy and often rather green. Both sexes have black antennae. Adults feed on other flies attracted to the dung, but the larvae feed on the dung itself. The dung of horses, deer and sheep is also eaten.

SIZE 10 mm.
HABITAT Light woodland and most open habitats, but most common on grazing pastures.
RANGE All Europe.
SEASON April–October.
SIMILAR SPECIES Several related species are very similar but have orange antennae.

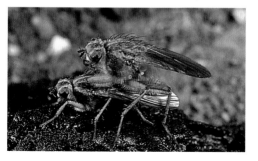

Phryganea grandis

The female, shown here, is one of Europe's biggest caddis flies. It is easily identified by its wing pattern. Males are smaller and lack the black streak. Look for the large spines or spurs on the legs. There are two on the front leg and four on the other legs. The larvae live in still and slow-moving water and make cases with spirally arranged plant fragments.

SIZE 20–30 mm.
HABITAT Close to still and slow-moving water.
RANGE Most of Europe except far S.
SEASON May–August.
SIMILAR SPECIES P. striata female has black wing stripe clearly broken into three short dashes.

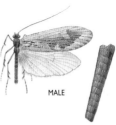

MALE

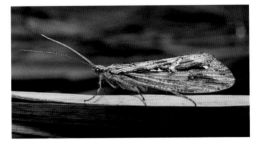

Limnephilus lunatus

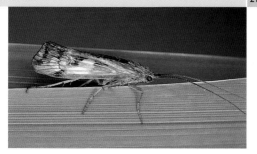

One of many similar species in which the forewing has clear patches and a very straight outer edge. Look for the pale crescent-shaped patch on the outer margin of the wing. The larvae live in all kinds of fresh water and make irregular cases with a wide range of debris.

SIZE 15 mm.
HABITAT Close to fresh water: often abundant in watercress beds.
RANGE Most of Europe.
SEASON May–November.
SIMILAR SPECIES Many other *Limnephilus* species are similar but generally lack the pale crescent at the end of the forewing.

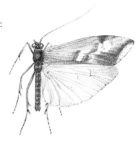

Horntail

Urocerus gigas

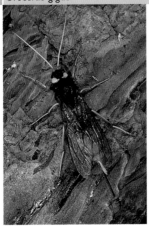

The female of this sawfly, shown here, causes much alarm because of its size and the formidable spine at the rear. But it is harmless and the spine is used for nothing more sinister than drilling into pine trunks and laying eggs. The grubs feed in the timber for two or three years. Males are smaller with largely orange abdomens. Also called a wood wasp.

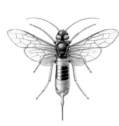

SIZE 30–50 mm (including ovipositor).
HABITAT Pine woods, but not uncommon in new houses because grubs often survive the sawmill and emerge from building timbers.
RANGE All Europe.
SEASON May–October.
SIMILAR SPECIES *U. augur* has a yellow band behind the eyes, not two separate spots.

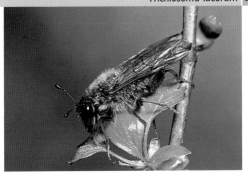

This sawfly flies fast, with a loud, buzzing sound. The hairs clothing its body range from dirty white to rich brown. Look for the black, clubbed antennae. Adults are less often seen than the plump blue-green larvae that feed on hawthorn hedges in the summer. The brown, sausage-shaped cocoons are easy to find in the winter, when the twigs are bare.

SIZE 20 mm.
HABITAT Hedgerows and scrub, wherever there are hawthorns.
RANGE N & C Europe except far N.
SEASON May–July.
SIMILAR SPECIES There are several closely related species. Birch Sawfly is longer and has orange antennae.

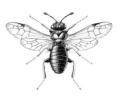

Rhogogaster viridis

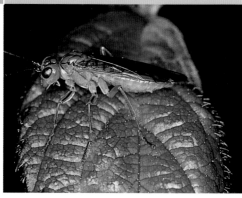

Look for the uniform bright green stigma on the front edge of the wing to distinguish this from several other green and black sawflies. There is always a bold black stripe on the top of the abdomen, sometimes covering the whole upper surface. The adults eat other insects, which they usually catch on flowers. The larvae feed on a wide range of woody and herbaceous plants.

SIZE 10–13 mm.
HABITAT Woods, hedgerows and scrub.
RANGE Most of Europe except far N.
SEASON May–July.
SIMILAR SPECIES Several, but most have less black on the abdomen.

This common sawfly is one of several yellow-banded, wasp-like species, but is distinguished from most of them by its stout orange or yellow antennae. Look also for the yellowish-brown front edge of the forewing and the dark smudge near the tip. Adults frequent flowers, especially the heads of hogweed and other umbellifers, while the larvae feed on mulleins and figworts.

SIZE 10–15 mm.
HABITAT Rough, grassy places.
RANGE All Europe.
SEASON May–August.
SIMILAR SPECIES Many, but most have black antennae, usually tapering to the tip.

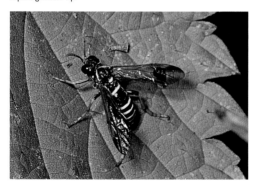

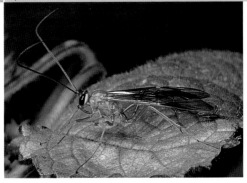

One of the ichneumons – parasitic insects – that lay their eggs in various caterpillars. The grubs develop inside the caterpillars and gradually destroy them. This species commonly comes to lighted windows and moth traps at night. Look for the markedly triangular scutellum, but beware the female's ovipositor, which can deliver a painful jab.

SIZE 15–20 mm.
HABITAT Almost anywhere: common in many gardens.
RANGE Most of Europe.
SEASON June–October.
SIMILAR SPECIES Many, some with a dark tip to the abdomen. *Netelia* species have a tiny, more or less circular cell in the outer part of the forewing, and a less triangular scutellum.

One of several red-banded ichneumons with a cream or yellow scutellum and cream spots at the rear of the abdomen. The legs are yellow and black. This insect is commonly seen on the flower heads of umbellifers. It lays its eggs in various caterpillars, especially those of the swift moths.

SIZE 10–15 mm.
HABITAT Hedgerows and other grassy places.
RANGE Most of Europe.
SEASON All year, but hibernates through the coldest months.
SIMILAR SPECIES Several very similar species; detailed examination is necessary to distinguish them.

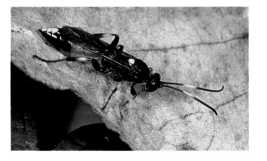

Ruby-tailed Wasp

220 *Chrysis ignita*

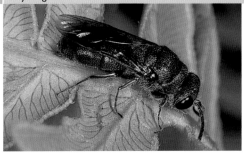

The head and thorax of this insect, also called a jewel wasp, are blue with strong green reflections when seen at certain angles. The ruby abdomen has golden reflections and four teeth at the tip. The female lays its eggs in the nests of various mason wasps (p.233), where its grubs develop. It is therefore often called a cuckoo wasp.

SIZE 5–15 mm.
HABITAT A wide range, including gardens: commonly seen on walls and tree trunks.
RANGE All Europe.
SEASON April–September.
SIMILAR SPECIES Many other *Chrysis* species differ only in the degree of sculpturing on the body. *C. fulgida* has a deep blue first abdominal segment.

Despite its formidable appearance – it is one of Europe's largest wasps – this insect is harmless. The male (illustrated) is smaller than the female (shown in photo), and has a black head. The wings have a metallic sheen. The red abdominal hairs are often missing and the yellow spots often link up to form two bands. Adults sip nectar, but the grubs are parasites of rhinoceros beetles (p.147).

SIZE 20–40 mm: wingspan up to 60 mm.
HABITAT Hot, sunny, flower-rich places.
RANGE Mediterranean.
SEASON May–August.
SIMILAR SPECIES Several smaller, but otherwise similar species live in S & C Europe.

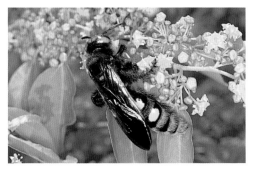

Harvester Ant

Messor barbara

This ant is most likely to be seen dragging seeds back to its underground nest. A mound of empty husks usually surrounds the nest entrance. The body is dark brown or black and very shiny, and the head is either black or chestnut. Look for the two distinct segments of the waist. Some workers have much bigger heads than others. They use their large jaws to crack the seeds.

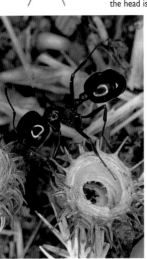

SIZE 5–12 mm.
HABITAT Grassy places, including coastal dunes.
RANGE S Europe and the Atlantic coast of France.
SEASON All year, but dormant in winter.
SIMILAR SPECIES There are several closely related species in S Europe.

Wood Ant

Formica rufa 223

One of several large mound-building ants. Look for the largely black head and abdomen, and the reddish-brown thorax. The head is hairless. Note the leaf-like scale, characteristic of all *Formica* species, between the thorax and the abdomen. The ants do not sting, but fire formic acid from the rear when disturbed. They feed mainly on other insects.

SIZE 10–12 mm.

HABITAT Woodland, building large nest mounds with leaves and other debris.

RANGE All Europe except Scotland and far N.

SEASON All year, but dormant in nest in winter. Mating flights May–June.

SIMILAR SPECIES *F. aquilonia* has long hairs on back of head. There are several other very similar ants.

Ectemnius cavifrons

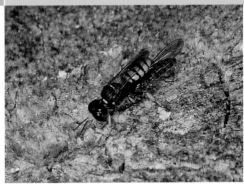

One of the solitary digger wasps that excavate their nests in dead wood and stock them with paralysed flies. The wasp shown here has caught a hover-fly. Victims are often caught on flowers, especially those of umbellifers. Unlike the mason wasps (p.233) and the social wasps (p.234), digger wasps lay their wings flat over the body at rest.

SIZE 11–17 mm.
HABITAT Any flowery area with dead wood for nesting: not uncommon in garden log piles.
RANGE Much of Europe except far N.
SEASON June–October.
SIMILAR SPECIES Many digger wasps have similar colours and they are not easy to distinguish.

Field Digger Wasp

This common species can be distinguished from most other black and yellow digger wasps by the large yellow spot on the scutellum and the elongated waist – almost like a stalk connecting the thorax and abdomen. It excavates its nest in light, usually sandy, soil and stocks it with flies, especially hover-flies.

SIZE 10–15 mm.
HABITAT Open places on well-drained soils.
RANGE Most of Europe except far N.
SEASON May–September.
SIMILAR SPECIES The much rarer *M. crabroneus* has paler markings and reddish antennae.

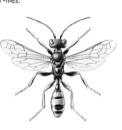

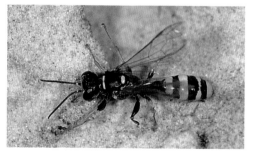

Bee-killer Wasp

Philanthus triangulum

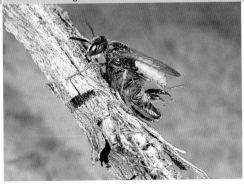

The female catches and paralyses bees, usually while they are feeding at flowers, and carries them to the nest slung upside down under her body. The nest is a burrow in sandy soil and the paralysed bees form a larder for the wasp's grubs. The wasp's abdomen usually has a line of small black triangles down the centre. A major enemy of honey bees.

SIZE Male 8–10 mm: female 12–17 mm.
HABITAT Open areas on light, usually sandy, soils.
RANGE Most of Europe except far N. Rare in British Isles, although it has been increasing recently.
SEASON July–September.
SIMILAR SPECIES Several wasps are superficially similar, but usually have more black on the abdomen and more slender antennae.

One of several very similar black and orange digger wasps that stock their burrows with paralysed crickets and grasshoppers. This one specialises in *Ephippiger* species (see p.63). The victims are too heavy to carry, so they are dragged along by their antennae, as shown here. A single egg is laid on the victim, which is gradually consumed by the resulting grub.

SIZE 20–30 mm.
HABITAT Sandy areas with plenty of bare soil.
RANGE SW Europe, including much of western France.
SEASON June–September.
SIMILAR SPECIES A dozen or more live in S Europe but are not easy to distinguish. They rarely capture *Ephippiger* species.

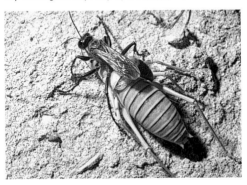

Sand Wasp

228 *Ammophila sabulosa*

The front part of the abdomen is like a slender stalk, gradually increasing in diameter to merge with the rear part. Look for the entirely black legs and the blue sheen at the tip of the abdomen. This solitary wasp excavates nests in sandy ground and usually stocks each burrow with a single non-hairy caterpillar.

SIZE 15–25 mm.
HABITAT Heathland and other sandy areas.
RANGE All Europe except Scotland and far N.
SEASON May–September.
SIMILAR SPECIES *A. pubescens* has no abdominal blue sheen.
Podalonia and *Sphex* species are stouter, with a shorter abdominal stalk sharply separated from the rest of the abdomen.

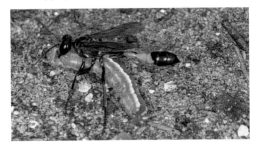

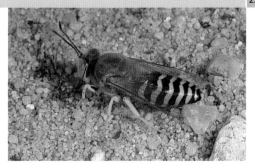

This digger wasp resembles some of the social wasps (p.234), but differs in laying its wings flat over its body at rest. Look for the pale, bulging eyes, which are not notched on the inner margin, and the comb of stout hairs on each front leg. Best developed in the female, these hairs are used for digging the nest burrow. The burrow is stocked with flies.

SIZE 10–25 mm.
HABITAT Sandy places, including dunes and river banks.
RANGE S & C Europe except British Isles.
SEASON May–August.
SIMILAR SPECIES Several related species live in S Europe. Social wasps are superficially similar, but have notched eyes and fold their wings along the sides of the body at rest.

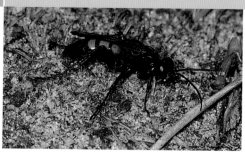

The three red abdominal bands distinguish this spider-hunter.
Look also for the brush of hairs on the female front leg and the
stout bristles at the tip of the abdomen. Females are most often
seen running over the ground in search of wolf spiders with which
to stock their nests. Both sexes sip nectar from hogweed and
other umbellifers.

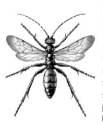

SIZE 7–14 mm.
HABITAT Heathland and other sandy places.
RANGE Much of Europe except Scotland
and far N.
SEASON Active March–September: females
hibernate in burrows and reappear in spring.
SIMILAR SPECIES There are many related
species, differing slightly in abdominal
pattern. Some digger wasps (see p.224) also
have similar colours.

Look for the slender, bell-shaped first segment of the abdomen, sharply separated from the pear-shaped rear section. The insect shown here is moistening particles of sand and clay with saliva and forming them into a little ball. The material will be used to build a nest like a lump of mud on a rock or a wall. The nest stocked with small caterpillars to feed the wasp's grubs.

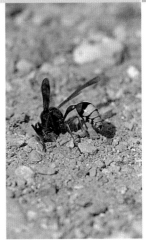

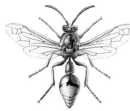

SIZE 15–25 mm: wingspan 30–40 mm.
HABITAT A wide range, but often near water and not uncommon around houses.
RANGE S & C Europe, but not British Isles.
SEASON June–August.
SIMILAR SPECIES None.

Look for the distinctly bell-shaped segment at the front of the abdomen. The wings are folded along the sides of the body and do not cover the abdomen at rest. The female uses sand and clay to make a vase-shaped nest, which she stocks with small caterpillars and in which she lays a single egg.

SIZE 9–15 mm.

HABITAT Heath and moorland. The nest is commonly attached to heathers and other plants.

RANGE Most of Europe except far N, but confined to southern England in the British Isles.

SEASON June–September.

SIMILAR SPECIES Several related species, differing slightly in pattern, live in S Europe.

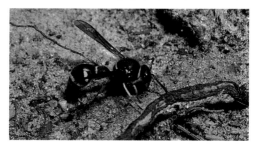

Mason Wasp

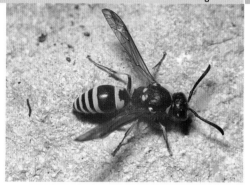

One of many similar solitary wasps that make their nests with mud or clay. They are not easy to distinguish because many of the diagnostic features are on the underside, but this species usually has a square black mark at the front of the abdomen. It nests in all kinds of crevices. The nest is stocked with small caterpillars.

SIZE 9–13 mm.
HABITAT Almost anywhere with trees, rocks or walls in which it can nest: common around houses.
RANGE S & C Europe, but not Ireland.
SEASON April–September.
SIMILAR SPECIES *A. parietinus* and *A. parietum* have similar patterns and habits and accurate identification requires detailed examination.

German Wasp

234 *Vespula germanica*

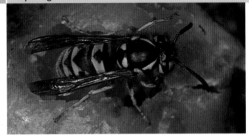

This and the Common Wasp (*V. vulgaris*) are the commonest of the social wasps that buzz around our food in late summer. Look for the prominent bulge on the yellow thoracic stripe. The face usually has three black spots, and workers and queens have four yellow spots at the rear of the thorax. Wings are folded along the sides of the body at rest.

SIZE 12–20 mm: queens much bigger than workers.

HABITAT Woods, hedgerows and other rough places: nests in holes, often in buildings.

RANGE All Europe except far N.

SEASON May–October, but hibernating queens can be found throughout the winter.

SIMILAR SPECIES Common Wasp has no bulge on the thoracic stripe and has an anchor mark on its face.

Larger and often blacker than our other black and yellow wasps, this species is best identified by the slender black bar running down the face. Look for the slender stripes and four yellow spots on the thorax. Both thorax and abdomen are sometimes tinged with red. The wasp hangs its nest in bushes.

SIZE 15–30 mm.

HABITAT Woodland, scrub, hedgerows and gardens.

RANGE S & C Europe: only recently established in British Isles, but now spreading rapidly northwards.

SEASON May–October, with queens hibernating through the winter.

SIMILAR SPECIES Queens of other species are often similar but have different face patterns.

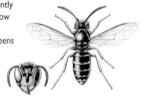

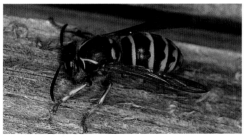

Vespa crabro

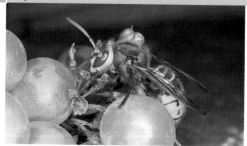

Europe's largest social wasp, the Hornet is easily recognised by its brown and gold pattern. Note the deeply notched eyes, typical of the social wasps. It nests in hollow trees and other cavities and feeds its grubs on other insects, including butterflies. The adults, less aggressive than most other wasps, enjoy fruit and also drink sap oozing from damaged trees.

SIZE 20–35 mm.

HABITAT Anywhere with trees, including gardens.

RANGE Most of Europe except far N: mainly southern in British Isles and absent from Ireland.

SEASON March–October, but hibernating queens can be found throughout the winter.

SIMILAR SPECIES None, although some hover-flies are excellent mimics (see p.200).

The paper wasps are closely related to the other social wasps, but the abdomen is hairless and it tapers to the front instead of being square. Paper wasps live in small colonies and the nest, shown here, is a single layer of cells with no protective envelope. The grubs are reared mainly on caterpillars.

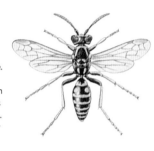

SIZE 10–15 mm.
HABITAT Almost anywhere other than dense woodland: commonly nests under eaves on buildings.
RANGE S & C Europe, but a rare visitor to British Isles.
SEASON April–October: young queens hibernate.
SIMILAR SPECIES There are many in S Europe. Some mason wasps (see p.233) are similar but have only one spur on the middle leg: paper wasps have two.

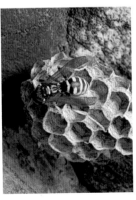

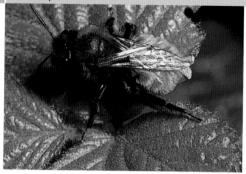

The female, shown here, is immediately identifiable by the black head and bright orange abdominal hairs. It often feeds at the flowers of gooseberries and currants. Sometimes called the lawn bee, it often nests in lawns and throws up little volcano-like heaps of soil around its burrow. Males are more slender and essentially black with scattered pale hairs.

MALE

FEMALE

SIZE 10–12 mm.
HABITAT Most open areas with light soil: common in parks and gardens, even in towns.
RANGE S & C Europe except much of the SW.
SEASON March–May.
SIMILAR SPECIES None.

Wool Carder Bee

Look for this bee on plants with woolly leaves. The female gathers the hairs, rolls them into a ball, and uses them to line her nest in a hole in timber or masonry. Look for the yellow or orange spots on each side of the abdomen – characteristic of all *Anthidium* species – and the completely black thorax.

SIZE 8–15 mm, males much bigger than females.
HABITAT Woodland edges, hedgerows, parks and gardens, wherever nest holes and lining material can be found.
RANGE Most of Europe except far N.
SEASON June–August.
SIMILAR SPECIES Several similar bees live on the continent; some have yellow borders to the thorax.

Osmia rufa

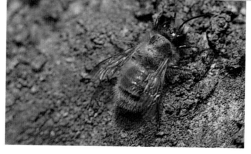

MALE

This plump, rounded bee has a black thorax and reddish hairs on the abdomen – much denser in the female, shown here, than in the male. The female is noticeably larger than the male and has two small black horns just under her eyes. Females make mud nests in a variety of cavities, often tunnelling in the mortar of old walls if they cannot find existing holes.

FEMALE

SIZE 10–15 mm.
HABITAT Almost anywhere with sufficient flowers and nest sites: common in gardens.
RANGE S & C Europe.
SEASON April–July.
SIMILAR SPECIES There are many closely related and similar species.

The insect that is responsible for carving oval and semicircular pieces from rose leaves in the garden. The pieces are taken to the bee's nest cavity – usually in timber – and used to make sausage-shaped cells for the grubs. Look for the bright orange pollen-gathering hairs under the female abdomen. The top of the abdomen has a marked hollow at the front.

MALE

FEMALE

SIZE 10 mm.
HABITAT Gardens, woodland margins and hedgerows.
RANGE Most of Europe except far N.
SEASON May–August.
SIMILAR SPECIES There are several similar leaf-cutters, all with a scooped-out abdomen.

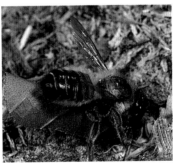

Nomad Bee

Nomada goodeniana

Despite its wasp-like appearance, this insect is a bee. Look for the brown antennae. It makes no nest and lays its eggs in the nests of other solitary bees, where its grubs kill the rightful occupants and then eat the stored food. It is therefore also called a cuckoo bee. Because it collects no food, it has no pollen-gathering hairs and, like its relatives, it is almost naked.

SIZE 10–12 mm.
HABITAT Most open habitats on well-drained soils.
RANGE Most of Europe.
SEASON April–June: sometimes a second brood later.
SIMILAR SPECIES Many closely related species. Many digger wasps are also very similar but usually have black antennae.

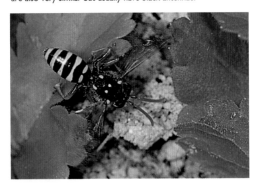

The male, shown here, has a bright yellow face and antennae about as long as the body. The female is much darker, with shorter antennae, a hairier abdomen and more obvious pale bands at the rear. The bees nest in well-drained soil and throw up volcano-like mounds of soil around the entrances. The male bees are among the main visitors to bee orchids in the southern half of Europe.

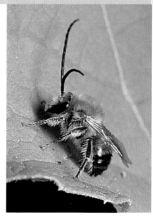

SIZE 10–15 mm.
HABITAT Rough grassland and heaths.
RANGE Most of Europe, but uncommon in British Isles.
SEASON April–July.
SIMILAR SPECIES Several live on the continent.

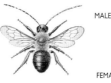

MALE

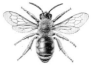

FEMALE

Honey Bee

Apis mellifera

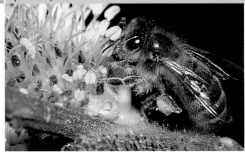

The bee that provides all our honey. It differs from other bees in the long, narrow cell near the wing-tip. Most Honey Bees live in hives in Europe, but there are many wild colonies in hollow trees. The bee shown here is a worker. The abdominal pattern varies and the orange patches are not always present. Males or drones are plumper, with longer antennae.

DRONE

SIZE 10–15 mm.
HABITAT Anywhere with plenty of flowers.
RANGE All Europe. Originally a native of southern Asia, domesticated strains are now found almost all over the world.
SEASON All year, but dormant in winter.
SIMILAR SPECIES Many bees are superficially similar but none has the long cell near the wing-tip.

The male, shown below, can always be recognised by the yellow face and the fan of long hairs on each middle leg. The female is jet black with orange pollen brushes on the hind legs. Although similar to a bumble bee, the Flower Bee has a faster, darting flight with a high-pitched whine. It can hover while thrusting its long tongue into flowers.

MALE

SIZE 12–18 mm.
HABITAT Gardens, hedgerows and other flowery places: nests in the ground and in walls.
RANGE Most of Europe except northern British Isles.
SEASON March–June.
SIMILAR SPECIES Several species are superficially similar, but the males lack the fans of hairs.

FEMALE

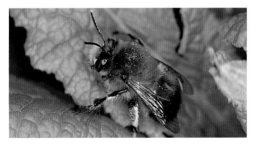

Carpenter Bee

Xylocopa violacea

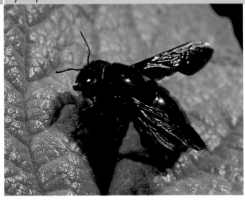

This large bee has a shiny black body and smoky-brown wings that reflect blue and violet when viewed from certain angles. It flies noisily from flower to flower and can be quite frightening, but it is not aggressive and rarely stings. It digs nest burrows in timber – hence its name.

SIZE 20–30 mm.
HABITAT Flowery places, including gardens.
RANGE S & C Europe, but a rare visitor to British Isles.
SEASON August–October and again in spring after hibernation.
SIMILAR SPECIES Several other *Xylocopa* species live in S Europe. *Megachile parietina* is smaller, with the outer part of the wing paler than the rest.

The lemon-yellow collar and second abdominal segment and the white tail identify this species. Like other bumble bees, it lives in colonies containing three castes – queens, males and workers. The latter are the most numerous. Queens resemble workers but are much bigger. Males are less common and often differ in pattern.

SIZE 10–20 mm.

HABITAT Almost anywhere: nests in the ground.

RANGE All Europe.

SEASON February–September: young queens sleep through winter and start new colonies in spring.

SIMILAR SPECIES Scutellum and first abdominal segment of *B. hortorum* (p.248) are yellow. Several others are superficially similar.

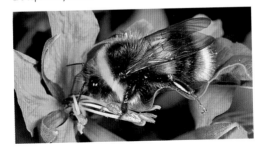

This rather long-haired bumble bee has a yellow collar, scutellum and first abdominal segment, and a white tail. Look for the shiny hind tibiae, fringed with stiff hairs. Found in all queen and worker bumble bees, these form the pollen baskets and are often bulging with pollen. This species nests on or just under the ground. As with other bumble bees, only the new queens survive the winter.

SIZE 10–22 mm.

HABITAT Almost anywhere: one of the commonest bumble bees in gardens.

RANGE All Europe.

SEASON March–September.

SIMILAR SPECIES White-tailed Bumble Bee (p.247) lacks yellow scutellum.

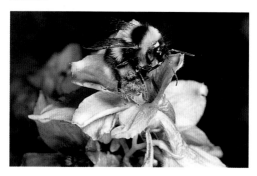

Buff-tailed Bumble Bee

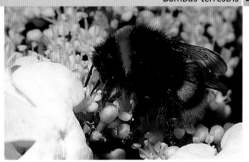

Look for the orange or golden (not lemon-yellow) collar and second abdominal segment. The tail is either buff or white in queens and usually white in workers, although it may be tinged with brown. The bee nests in the ground. The young queens, together with those of other bumble bee species, feed avidly at sallow catkins in early spring.

SIZE 10–25 mm.

HABITAT Almost anywhere: often common in gardens.

RANGE Most of Europe except northern Scotland and far N.

SEASON March–August.

SIMILAR SPECIES The much rarer *B. soroeensis* is similar but the yellow is usually paler.

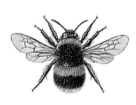

Red-tailed Bumble Bee

Bombus lapidarius

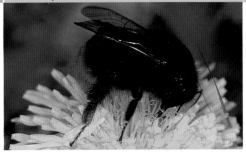

Queens and workers can be identified quite easily by the long black hair, red tail and black pollen baskets (see p.248). The male has a broad yellow collar. This species nests in the ground, often under flat stones.

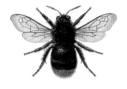

SIZE 12–25 mm.
HABITAT Open country of all kinds, including coastal dunes, but not uncommon in gardens.
RANGE Most of Europe except far N.
SEASON April–August.

SIMILAR SPECIES *B. ruderarius* has reddish pollen baskets. *Psithyrus rupestris*, a cuckoo bee that lays its eggs in *lapidarius* nests, is very like *lapidarius* but has sparse hair and is rather shiny. It has no pollen baskets.

A very variable bee, with a thin and rather scruffy coat. The thorax is normally orange, as shown here, but often has a good deal of black or grey hair in it. The queen's abdomen may be largely orange, but worker abdomens are normally dark brown. The bee nests on or above the ground, commonly in old birds' nests and nest boxes. It is often called a carder bee.

SIZE 10–15 mm.
HABITAT Almost anywhere, but avoids the most exposed areas. Common in gardens and hedgerows.
RANGE All Europe.
SEASON April–November.
SIMILAR SPECIES B. muscorum and B. humilis, both uncommon, have orange abdomens with very little black.

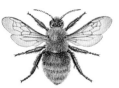

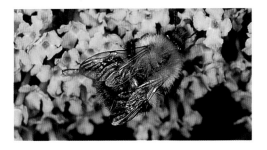

Index